COLOR PHOTOGRAPHY

GABRIEL BAURET

ASSOULINE

[PORT

n. from the Itali

[sheet-holder

prints by an art

work in the for

was originall

FOLIO

an "portafoglio"

(1722). Set of

st showing his

nat in which it

COLOR PHOTOGRAPHY

Aesthetics of Color

Color photography is an enormous subject. What is the best way to tackle it, and from what angle? Only a handful of books published in the United States, France, and Germany address the practice of color.[1] Most of these books were published in the early 1980s, and they don't represent recent artistic and creative developments. Histories of photography, starting with the pioneer in the field, Beaumont Newhall's *History of Photography*,[2] and contemporary titles by the American Naomi Rosenblum[3] and the Frenchman Michel Frizot,[4] have just one chapter on color. Treatments of the subject usually broach the topic in a more technical vein with an inventory and analysis of the various processes, but there is nothing resembling *Art de la Couleur*,[5] a survey on painting published forty years ago that still maintains its authority today.

In the last few years, however, several books have appeared that deal with a color in particular. For example, red and blue. This new rash of writers examines social and cultural uses of the color in question, along with its symbolism and its forms and meanings in art history. This series of publications certainly attests to renewed interest in color.

But none of this alters the fact that discussions about color emphasizing creative work—in other words, which favor an aesthetic approach over technical and historical considerations—are rare, especially in the field of photography. Much of what is said about the aesthetics of photography focuses on black-and-white work, possibly because it has a longer history. This history also has an ongoing effect on the actual evolution of creative work, as well as on the trends which punctuate 150 years of photography. Generally, though, the meaning of images is commented on more than form and style, and the social repercussions of a work, or, further, the artist's conceptual approach, offers more openings for the commentator's work, whereas the purely visual issues to which color is specifically related evades words.

Edward Steichen, *The Flat-Iron Evening*. New York, 1906. Gum bichromate print. 20" x 15".

The language of color is usually made up of metaphors borrowed from music: tone and tonality, scale, resonance, harmony and rhythm, when it is not a matter of hot and cold, terms borrowed, for example, from psychology or inspired by the theories that Goethe developed in his famous *Treatise on Colors*.[6] As if pure color constitutes a reality that is hard to put a name to. As if subtlety can only give rise to subjectivity and interpretation.

In addition to the primary and complementary colors, for example, of describing a specific red or blue, there is evident disagreement, usually to do with the use of the appropriate terms. This goes for the designation of the colors that make up the world around us, but the undertaking is even more delicate when the colors are re-created by the painter on his canvas—every artist creates a palette particular to him or her. As for colors produced by photographic chemistry, which, incidentally, the photographer cannot handle with as much freedom as the painter, any study of this issue will mention the fact that colors change with the various processes that have been introduced, one after the other, since the mid-nineteenth century.

Today, however, having been long kept at a distance by artists and critics who felt that black and white alone represented a real manner of expression in photography, color has established itself. It now dominates contemporary art-work. But the critical discourse on photography is still not altogether ready to analyze this evolution. Yet there is every reason to introduce and establish an aesthetic of color, and it is the aim of this essay to lay the foundations.

Color Processes

A photographer doesn't just shift willy-nilly from black and white to color. There are two ways of thinking at work here, and two specific types of creative activity. Technological advances have various effects on the direction creative work takes, and possibly more so in the field of photography—and film, which is an extension of photography—than in other visual arts. Conversely, the expectations of creative artists have opened up new areas of research, both optical and chemical.

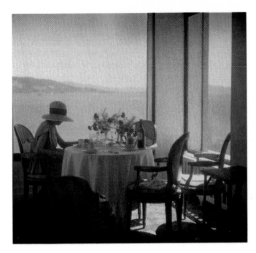

Jacques-Henri Lartigue,
*Bibi au restaurant
L'Eden Rock.*
Cap d'Antibes, 1920.
Autochrome.

In *La Chambre Claire*,[7] Roland Barthes stresses the fact that the very first photographers were scientifically minded people—it probably had to be that way—and, more exactly, chemists. This is why color represented new challenges: All photography historians, starting with Beaumont Newhall, agree that as soon as Nicéphore Niepce obtained his first pictures, he immediately felt the need to continue his research, so as to reproduce color. In his eyes, black and white was just a first phase, for that kind of imperfection left him, along with other photographic pioneers, dissatisfied. It was of paramount importance to take things further and make up for the absence of colors, and in this spirit the desire for progress won out over the visual use of already existing data and the exploration of their possible applications. Photographing colors was at issue, although taking photographs in color would be another step still.

While inventors Charles Cros, Louis Ducos du Hauron, and others explored the various processes and procedures that would make it possible to reproduce colors in the latter half of the nineteenth century—processes that were still fragile and unstable—cameramen elected to sidestep the problem by coloring their black-and-white prints by hand. The Italian-born photographer Felice Beato put together his entire oeuvre using this "ploy."[8] In 1861, in Japan, he started to work with the watercolorist Charles Wirgman, who would color his photos. This

collaborative effort helped Beato develop his production of albums considerably, because photography advanced in leaps and bounds on a technical level.

Until the 1930s, and in areas as diverse as portraits and fashion, the photograph was recolored by hand in studios in major cities and small provincial towns. Famous photographers like Cecil Beaton resorted to this process, but there are also countless photos taken by anonymous photographers. And today, photographers like the Czech Jan Saudek, the Frenchman Marc Le Mené and, in a more fantasy-oriented key, Pierre et Gilles, are still carrying on this tradition. In the nineteenth-century context, which is when the debate on the theme "Is photography an art?" began, the practice of coloring black-and-white prints by hand certainly altered the way this serious matter was broached. The process gave the photograph extra value. Every image became a unique piece, and the manual interference on a photo brought the photograph closer to painting. But the colors were obviously different from those on the painter's palette; they were light and almost transparent, and easily blended in with the texture of the paper, mingling with black-and-white values.

In the nineteenth century, prints had a slightly yellowish-brown or sepia hue, depending on the printing process, and the toning used by photographers. The colors of hand-painted photographs were in harmony with these already existing values, acting as their extension, without any breaks or clashes. They never completely covered them, but wove a bond with them.

When we approach the colors of photography, comparisons to the colors of painting are inevitably made — although there is a great deal separating the two, both scientifically and practically speaking. Photographic color is closely linked with the phenomenon of light, whereas the very principle behind pictorial color is connected with the culmination of an application of different forms of matter on a surface. The photographer uses chemical elements that are contained within a film, and he cannot separate one from another. He opts for an overall sort of chemistry, which forms a specific whole. The painter, however, can mix as many colors as he wishes, colors he chooses separately — different pigments from a variety of sources. There are even artists — among the cubists in particular — who introduced colored matter that was alien to the pigments of their tubes.

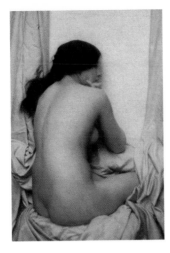

Gustave Marissiaux,
Nu.
1911–1914. Sury process.

Jean-Claude Lemagny therefore writes: "Color photography ought to be called colored photography, because the colors in it are present beforehand."[9] In a way, the photographer is reliant upon film's ability to react a particular way; the only option is to change the film to go for other scales of color reactions.

Addition and Subtraction

Color photography underwent, firstly, the advancement of sensitive surfaces, for each surface has chemical properties and, consequently, specific reactions—in other words, dominants. These days, certain films are said to have a hot or cold general tonality or key; they are said to hold more colors than others, and their colors are either very or not very saturated, and so on and so forth. In the early twentieth century, the "autochrome" process developed by the Lumière brothers—one of the first that could be mastered by cameramen other than the inventors themselves—came with very identifiable properties: a certain grain combined with a particular range of colors (characteristics linked with the use of potato starch). The process was based on an additive synthesis. This meant that the color factor in a photograph was obtained by the specific mixture of three colors contained in the sensitive plate. Subsequent processes, which would lead

to the development in the 1930s of modern films—primarily Kodachrome and Agfacolor—would be based on a subtractive synthesis: the image captured on the film had a wealth of certain colors, which it abandoned by proceeding through corresponding chemical components. On the same principle of subtractive synthesis, the color of the things surrounding us is dependent upon the light that illuminates them. It comes from the subtraction or screening out, by way of their material, of a white light component.

The physicist Isaac Newton demonstrated that light could be broken down into several colors. And if light is not white—as anyone can see in the morning and the evening—the color of the objects it illuminates varies just as much. Otherwise put, if the composition of light changes, the color of whatever it illuminates also changes. Color reproduction processes are derived from Newton's observation, but they are applied in differing ways. This, in turn, produces different renderings of color. And these differences have to do with the fact that colors are not directly reproduced on the sensitive surface of the glass plate or the photographic film.

In *Nouvelle histoire de la photographie*, Michel Frizot writes: "When it became evident that color would not be comprehensively and precisely duplicated on a sensitive surface, people turned toward reproduction processes which break color down and then put it back together again, thus adding additional modifications. The responsibility for representing colors was shifted to these highly diversified processes." Because the photographic reproduction of color is at issue, it appears that there is no truth possible, just as there is no perfect balance of the colors in a film, and no pure white light in nature. And in Henri Cartier-Bresson's eyes, the colors of photography would never have as many shades as those contained in the range of greys between black and white: "Unlike black and white giving the most complex range, color, conversely, offers just an altogether fragmentary range."[10]

Even if people like Alexander Liberman, art director of *Vogue* magazine, waxed enthusiastic in the 1950s over the future opening up for color photography—especially in magazines—there were widespread reservations, including those vented by Henri Cartier-Bresson and Jean-Claude Lemagny: "Color is accidental, black and white is existential."[11] This is probably because, after many

Léon Gimpel. Billancourt (last remnants of the Farman factory),
February 27, 1917.
Autochrome.

decades of development, as Liberman rightly recalls: "Technically speaking, color photography was invented in around 1870, but the first usable film was not marketed prior to 1935"[12]—no color reproduction process was yet completely satisfactory, and no such process held sway universally. And this applied both to taking photographs and printing them. For if you manage to capture colors on film, you still have to know how to retranscribe them on paper, based on the negative and positive alike. And the issues that arise during the printing process therefore echo those of taking photos. The scope of the color range, its balance and its dominants, offer as many possible variants as there are established processes: dye transfer, cibachrome, carbon printing, C41 and, these days, digital printing. And in every period, a particular process emerges, becoming the colors of an age—a bit like the Technicolor age in film.

The Paradox of Colors

For a long time, photographic colors have had a "strangeness" that is referred to by the historian Michel Frizot. There is a discrepancy between the image and its model, between the atmosphere of a color photograph and the atmosphere of reality—or, more accurately, the perception we may have of reality. For we have

known, ever since Goethe's theories, that the perception of colors is subjective. The art historian Louis Marin observes in his preface to a book about color written by Manlio Brusatin, "Goethe seems to be the symbolic name of the subjectivity of the perceiving being."[13]

Perhaps more so than in other representational art, color photography raises the question of the relationship between the image and our perception of the world. The principle of "camera obscura," which lies at the root of photography, has long been identified with the way the eye works. An image is deposited at the back of the camera the way it would be deposited on the surface of the retina. It is the brain that constructs the image, based on the information transmitted to it through the eye. If the "current" is poor, the image is not properly re-created. This is what happens, for example, with color-blind people, who reverse the perception of certain colors. We also all have our own personal way of naming colors. The invention of color draws us closer to reality, but never actually attains it. Color reproduction through photography remains uncertain. We might even say that it betrays our perception in wanting to better serve it. A painter who applies colors in a brutal way is at times closer to our perception of things. And if the art of color has taken time to find its footing in the history of photography, it is probably because a lot of photographers used to put themselves in a position that was linked to conformity with and imitation of what they were seeing. They could not and would not accept the difference; they didn't realize they had to come to a compromise with it. Nothing requires photography to confine itself to representing what the eye sees.

The Question of Style

Alexander Liberman writes: "It is rare for a photographer to have excelled in his use of color without having previously distinguished himself in the way he handles black and white." Quoting Ingres, who promotes drawing over painting, Liberman puts color photography in a similar relationship with black and white — a reliance on, and a subordination to its rules. In his opinion, black-and-white photography teaches one to define the essential values: "meaning, emotion,

composition, style." And it invites the photographer, bearing in mind the form of abstraction represented by black and white, to step back from both subject and reality, from the issue of resemblance, and from excessive detail. Liberman also gives voice to the idea that one must not be fooled by color. "Too many colors distract the viewer," observed the French filmmaker Jacques Tati. But just as the painter gradually stands back from the preliminary drawings for his canvases, from applying local tone and using a color that is confined within the colors of the object depicted, why should the photographer not let color "speak" for itself, and compose images based on what Johannes Itten calls "color in itself"?

The painter has slowly discarded the shackles of subservience to representation and headed for abstraction, relying on color. Julia Kristeva writes: "It is through color that the western painter started to dodge the limitations of the recitative and perspectival norm."[14] On the other hand, the photographer cannot free himself completely from the representation of reality. The photographic image only takes shape, on both the optical and the chemical level, insofar as something really does exist in front of the camera.[15] But if there is no inner organization of the different colored components of the image, the color photograph risks being just a subordination to reality—a representation devoid of identity, and thus of style. Or alternatively, as Edward Weston writes about many color photographs, it will just be a "colored-in black and white."[16]

Style, which is difficult to define within photography, is also bound up with the choice of a specific emulsion, combined with certain types of subjects, lights and colors. Sarah Moon, for example, was noticed in the 1970s through a particular treatment of color based on the use of Anscochrome film. This was a type of film that fulfilled her wish to "dirty" color, giving her a "cooked-up, sick color, a color-less color." These are terms that she used in an interview with Frank Horvat, who argues correctly that the grain of this film makes it possible to "reduce the surplus information being recorded by the camera."[17] It should be noted that creativity and style often come about through a deliberate reduction of the color range, or even calculated imbalance.

Today, it is not a given—as Liberman remarked half a century ago—that a good photographer must proceed by way of black and white. Color photography is a

particular way of thinking and a specific form of expression. There may be a larger gap forming between black-and-white enthusiasts and colorists—but can we call them this? The term conjures up a genre, if not a manner. Color photography is becoming so important, it is even tempting to talk in terms of a gap between the ancients and the moderns.

A Modern Expression of Color Photography

As photography historians like to emphasize, with the exception of the Lumière brothers' autochromes, the introduction of color, other than in an experimental form, dates from the 1930s. In 1986, the Photokina, one of the most important of all photographic events from both a technical and commercial point of view, celebrated half a century of color in an exhibition whose title incorporated the idea of "Modern Color Photography." It reminded us that, at the very same moment, so to speak, in two countries where the photographic industry is extremely active, two types of film made their appearance in the market place: Kodachrome in the United States in 1935 and Agfacolor in Germany in 1936.

It was probably the cinema, Michel Frizot notes, that stimulated research and sped up the development of color films—cinema and photography were already both using the 35mm format. Economically speaking, though, the role played by the press in general, and fashion magazines in particular, should not be overlooked. The covers of magazines had been the work of illustrators, but photography wasted little time ousting illustration—and color printing was enjoying a veritable boom. Color was on covers, but also on inside pages featuring advertisements.

During the latter half of the 1930s, fashion photographer Louise Dahl-Wolfe earned acclaim in *Harper's Bazaar* magazine for her use of elegant colors and meticulous forms. Erwin Blumenfeld's inventive and daring pictures, which enhanced the covers of rival *Vogue* magazine, also attracted considerable attention. It is interesting that, for Louise Dahl-Wolfe, the culmination of her work was the printed page; the creative process went on until the moment when she made the final color adjustments with the printer. The principles of photogravure and

Léon Gimpel.
Issy-les-Moulineaux,
May 22, 1910. Autochrome.

exposure were not altogether alien to the techniques of photographic printing. But for Louise Dahl-Wolfe and many other photographers who followed in her footsteps, particularly in the field of fashion, exposure was probably more reliable than printing.

In another branch of the press—photojournalism—it was some time before color was used. Several photographers worked in color within the famous Farm Security Administration, a United States government agency that documented the aftereffects of the Great Depression. Their pictures weren't published until 1953, when *LIFE* published a work entirely in color—Ernst Haas's photographs of New York—although most of its covers and inside pages were still in black and white. This publication, divided up over several issues, was such a milestone that the title of the subject and the fact that it was presented in color were mentioned on the magazine cover. Ernst Haas was the first Magnum member to make a radical commitment to working in color, while that agency remained one of the stoutest bastions of black and white.

It is worth asking why color occurred so recently in the history of the press. There are several explanations. The first is economic—the cost of color was much higher than black and white. There was also reluctance to the excessive realism introduced by color—whereas black and white gave a less direct and less raw

vision of the world. Just think back to *LIFE* magazine and the Larry Burrows reports published in the late 1960s on the Vietnam War, and the gripping effect achieved by some of his two-page color spreads. Today color is commonplace. Its demand is ever growing, and the savings represented by black and white are being sidelined.

On the outer limits of these different publications, and what is known as applied photography, color was being experimented with in the United States by the major standard-bearers of the various aesthetic trends that would punctuate the first fifty years of the century. After Edward Steichen, who investigated several processes in the early years of the century, and who espoused a style that was an extension of pictorialism, Edward Weston, Arthur Siegel, and Harry Callahan lent a truly modern dimension to the use of color in the 1940s. Their pictures were accompanied by manifesto-like statements: "The bias that many photographers have with regard to color photography comes from the fact that they don't know what to make of color as form."[18]

The Colors of Ordinary Life

In 1976, John Szarkowski was head of the photography department at the Museum of Modern Art in New York (MoMA), which was one of the most groundbreaking places in terms of recognizing and promoting photography as a form of artistic expression. Szarkowski showed the work of William Eggleston, who he described as the "inventor of color photography." Color photography made its appearance in a museum that had, until then, only accommodated it on an occasional basis. We actually have to go back to 1950 to come across a meaningful exhibition, "All Color," which was put on by Szarkowski's predecessor, who was none other than Edward Steichen.

William Eggleston's photography followed in the wake of American "street photographers," who found the stuff with which to compose their pictures on the street and in the urban environment. He was greatly interested in urban settings, but he also ventured into the interiors of American homes to photograph their ordinary objects and decoration. In "Pleasures and Terrors of Domestic

Gabriel Lippmann,
Sainte-Maxime. 1890.
Interferential photograph.

Comfort,"[19] an exhibition organized at the MoMA by Peter Galassi, John Szarkowski's successor, Eggleston was a forerunner in this trend in contemporary photography, which also affected Europe and incorporated color in a significant way. Everyday color, be it dull or dazzling, was one of the key factors in the choice of subjects. "In one instance, color uplifts the visual decision, and in another it asserts the neutrality of the declaration."[20] Eggleston's color was clearly placed in the latter category—a color that was used to "show the deserted streets, boredom, and malaise of provincial life."[21]

In the United States, pop art has had a considerable impact in many artistic arenas; it revived artists' inspiration, prompting them to venture into the terrain of provocation. And at that particular time, color played a thoroughly decisive role— not any color, but industrial color, as opposed to the sophisticated, original and unique color that painters used for many centuries. The color of manufactured items, the color of cars and posters, color that comes from the street and popular culture, this new color burst into painting, which then took on a "hyper-realist" form. Needless to say, it also burst into photography, an art as close as you can get to reality. By using violent and saturated colors, American photographers like Pete Turner would produce pictures with very distinct graphics, and compositions based essentially on contrasts, at times bordering on abstraction.

The 1970s and early 1980s showed a marked taste for these bits and pieces of urban landscape. But the pictures remained very formal, and lacked depth in every sense of the word. They re-created surfaces devoid of vibration and human presence. Today, they seem like an illustration of the modern world, without critical nuance. Various European photographers, particularly in Germany, have also gone down this path, but all that remains today are caricatures, like those of Cheyco Leidmann, which were often conceived within the context of an advertising commission. Underpinned by printing techniques like the Cibachrome, the colors burst and sparkle, are arranged in dense and saturated flat tints, and are not so far removed from their models.

The Colors of the Landscape

Where this aesthetic of color—which is not an aesthetic—is concerned, we find a perpetuation of the more traditional photographic genre, with an emphasis on natural landscape, which would adopt color. Let us cite the example—particularly in the United States, where the landscape school was very busy—of Eliot Porter and Joel Meyerowitz, who were most inspired by seashores. Their style—and more specifically Meyerowitz's style—was hallmarked by nuances and a spare, sober style.

We also find these nuances in the works of the Italian landscape school in the 1980s—a landscape that is approached in a different way. The Americans have a tendency to sublimate nature and space, while Italians like Luigi Ghirri, Olivo Barbieri, Mario Cresci and Giovanni Chiaramonte, who are all featured in *Viaggio in Italia*,[22] incorporate within their landscapes the historical and archaeological heritage of Italy. The use of negative films, which break with a certain rawness in the colors typifying the transparent surfaces—with the possible exception of Kodachrome, which, as film, is slightly aloof, and has long been the favorite of travelling photographers—and the use of medium and large formats offering greater detail, unlike 35mm film, enables these photographers to re-create the subtle shades of the Italian landscape as well as the different qualities of light swathing it.

Today's Colors

In addition to the reliability and stability of the chemistry of colors, which we discussed earlier, there are artists looking for a pictorial type of rendering, as well as the possibility of varying the types of papers on which their pictures are printed. In France, for example, the Fresson laboratories perpetuated a carbon printing process that won over many photographers, including the American Sheila Metzner, who prefers tonal richness to the re-creation of details. Polaroid, with its direct and on-the-spot printing process, introduced new features in the 1980s, including among its various qualities a softness that is particularly suitable for depicting the skin.

Today, the palette has been further enhanced by new processes, and digital data in particular. But it is certainly not possible to gauge the whole range of future possibilities in terms of color quality, surface, and format. It is not a given, however, that artists feel reassured by all these opportunities, which also increase the risk of dispersal. Rather, artists must strive to establish their own limits if they want to develop a visual style that is individual.

The contemporary photography that has come to the fore in galleries over the past ten years or so, and is now conceived more for walls than for the pages of

books and magazines, combines an intensive use of color and the large format. Jean-François Chevrier called it the "picture-form" or "tabular-format."[23] The photograph is actually meant for the same space as large abstract canvases and historical paintings used to be. The present-day color printing processes encourage this new dimension of photography and its incorporation in the art market.

Two representatives of the contemporary German school, Andreas Gursky and Thomas Struth, who both use color and an occasionally monumental format, have recently come to notice as a result of the prices they fetched for their works at public sales. Where Gursky and Struth are concerned, the issue probably is not raised, but in many other instances, when it comes to the subjects of these new "pictures," one does sometimes wonder if they are really suitable for the large format, and if the use of color is in fact meaningful.

Some scenes come close to private life, and their details have no need to be systematically enlarged in this way. So there are current market trends that might, in some cases, prompt artists to operate in this way. Be that as it may, recent years have been marked, particularly in France, by a movement that promoted the everyday, making situations and objects previously regarded as insignificant, unexceptional, or even vulgar, attractive. And you get the feeling that the works of this movement invoke the works of photographers like Eggleston—who was involved some twenty years earlier.

It is obvious that the contemporary photographer, or the artist using the photographic medium, is renewing the traditional themes that fueled the history of photography. The documentary approach considerably broadens the application area, particularly under the influence of the British, which seems to be growing throughout northern Europe. And color, previously regarded as suspect, has played an active role in this broadening. The French school, deeply attached to the historic relationship between reporting and black and white, spontaneously associating the human, or even humanist subject with this type of style, is still putting up a little resistance to this trend.

But there is much to be said about the crucial role of British photography in color. Color underscores the ironic eye cast over society, and that irony is particular to the British mind. It is an almost constant feature in the work of Martin Parr—look

Louis Ducos du Hauron,
III/9. Anaglyphe
(stereoscopic photograph made
in two complementary colors).

at his close-ups of the cheap, popular food served up in his country, or the more recent work he is undertaking with cultural snapshots of Europe. The field of fashion photography has provocative images of pale, weary models filling the pages of avant-garde cultural magazines such as *The Face, iD,* and *Dazed and Confused.* This trend was subsequently picked up and sanitized by the Americans.

The use of color has also capsized the tradition of the nude—a visual and plastic tradition based essentially on the interpretation of the body's shapes and outlines using black-and-white values. With color, this tradition was broken, because the representation of the skin is poorer, harder to master. In the 1930s, Paul Outerbridge was one of the first people to take the risk, but it was more by combining the body with other subject matters that he put his best pictures together. In contrast, in the field of still life, color enriched the subject, and opened the way to new forms of composition.

Conceiving the World in Color

What is the precise contribution made by color to photography? Or, to borrow historian Beaumont Newhall's words: "How are we to define what is essentially

photographic in color as it is used by photographers?" There is no doubt that the color of a photograph is not the color of a painting. It is never totally independent of what is represented, but this doesn't stop it from being used visually, as is readily practiced by European photographers who draw color toward compositions in which we have lost sight of the subject. In this sense, there is a photographic beauty about color, or, otherwise put, there is a beauty in photographic color. But it is evident that color also makes a crucial contribution to the meaning of a picture, and its message.

Depending on the photographer, the subject, the genre and the period, color can be beautiful or ugly, showy, or neutral. But what undoubtedly matters most is the ability to tell works apart from each other, and identify them, whatever their dimensions—works that are based in an "existential" way on the color of those that are only occasionally or "accidentally" in color, if we may twist Jean-Claude Lemagny's words just a little. What also matters is—just the same way that the choice of photographs in this book expresses an intent—promoting those photographers and artists who conceive and dream of the world in color.

1. Roger Bellone and Luc Fellot, Histoire mondiale de la photographie en couleurs, des origines à nos jours, Paris, Hachette, "Réalités," 1981; Color as Form: A History of Color Photography, exhibition catalog, Rochester, George Eastman House, 1982; Sally Eauclaire, The New Color Photography, New York, Abbeville Press, 1981.
2. Beaumont Newhall, The History of Photography, New York, Little Brown, 1982 (revised and augmented edition). First edition, 1937.
3. Naomi Rosenblum, Une histoire mondiale de la photographie, Paris, Abbeville Press, 1992.
4. Michel Frizot, Nouvelle histoire de la photographie, Paris, Bordas/Adam Biro, 1994.
5. Johannes Itten, Art de la Couleur, Paris, Dessain et Tolra, 1967. Original edition published in Germany in 1961.
6. Johann Wolfgang von Goethe, Treatise on Colors (Zur Farbenlehre), foreword, introduction and notes by Rudolf Steiner, Paris, Triades, 1973.
7. Roland Barthes, La Chambre Claire: Note sur la photographie, Paris, Gallimard/Seuil, "Cahiers du cinéma," 1980.
8. Term used by Naomi Rosenblum, in her Histoire mondiale de la photographie, op. cit., with regard to "coloring in by hand."
9. Jean-Claude Lemagny, L'ombre et le temps. Essais sur la photographie comme art, preface by Gilles Mora, Paris, Nathan, 1992.
10. Henri Cartier-Bresson, L'imaginaire d'après nature, Fontfroide-le-Haut, Fata Morgana, 1996.
11. Jean-Claude Lemagny, L'ombre et le temps, op. cit.
12. Alexander Liberman, The Art and Technique of Color Photography, New York, Simon & Schuster, 1951.
13. Manlio Brusatin, Histoire des couleurs, preface by Louis Marin, Paris, Flammarion, 1986.
14. Julia Kristeva, "L'espace Giotto," in Peinture, cahiers théoriques, 2/3, Paris, CEDIC, 1972.
15. See on this subject the phenomenological approach to photography by Roland Barthes in his book La Chambre Claire (op. cit.).
16. Excerpts from the American magazine Modern Photography (1953) and quoted by Beaumont Newhall in his Histoire de la photographie, op. cit.
17. Frank Horvat, Entre vues, Paris, Nathan, Nathan Image, 1990.
18. Modern Photography, op. cit.
19. Peter Galassi, Pleasures and Terrors of Domestic Comfort, exhib. cat., New York, The Museum of Modern Art, 1991.
20. Jean-Claude Lemagny and André Rouillé (editors), Histoire de la photographie, Paris, Bordas, 1986.
21. Naomi Rosenblum, Une histoire mondiale de la photographie, op. cit.
22. Viaggio in Italia, Alexandrie, Il Quadrante, 1984.
23. Quoted by Dominique Baqué in his book La Photographie plasticienne, un art paradoxal, Paris, Editions du Regard, 1998.

The photography works are arranged here in the conventional way. The categories comply with those established by the history of painting: still lifes, nudes, portraits, and landscapes. As we know, however, photography has enhanced the way these genres have developed. For example, photographers have diversified documentary practice, while so-called history painting was often restricted to theatrical re-creations. Under the influence of contemporary art movements, new subjects have also been introduced, connected with a desire to invent other visual worlds or, conversely, take a more detailed look at everyday life and the urban environment. In some ways, the taste for the commonplace has replaced a systematic desire for originality. And color, whose spread has overlapped with the use of large formats, offers more options in this respect. But it no longer produces quite the same visual effects as in the past, because it is produced with different tools and on different surfaces.

In its own way, this book illustrates the evolution of photography. As far as photographers—or, if there is cause today to establish a subtle difference, artists—are concerned, they have been chosen for the undisputed place they once occupied as colorists. But the term "colorist" is simplistic and tends to suggest that the subject of the photograph is relegated to second fiddle. The people involved here are creative men and women who, for the most part, live and enact the photographic transaction with color. In the course of a journey or studio session, they never approach it haphazardly. It isn't an "extra" the way we talk of an "extra soul," it is essential to the creative process. Finally, the works featured here are representative of the arena in which photographers are likely to express themselves; they also correspond with the specific moment in which they have come about and found their place.

G. B.

Paul Outerbridge, *Nude standing at dressing table.*
Circa 1936. Carbo print. 15" x 11$^{1/2}$"

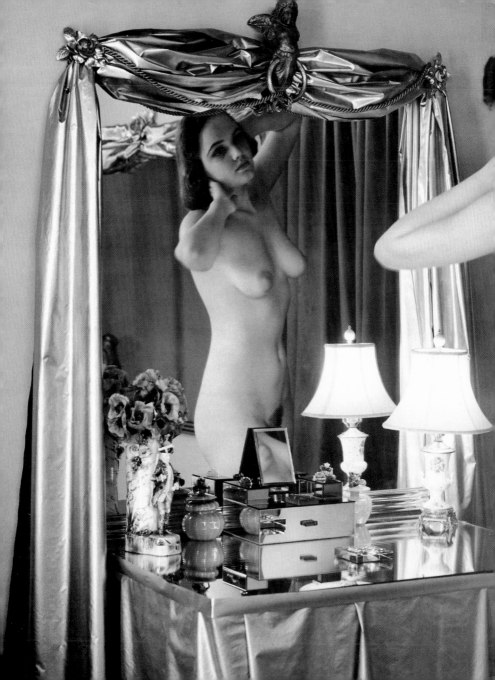

The pity about Polaroid is there is only one. Not much to play with. Color is friendly and one has to be careful of this. In color a red tulip is a red tulip and that's that. You have to think of something else if you want a red tulip in a picture.

Polaroid is like a sketch to see if my thinking is where I want it to be; it alleviates doubt.

It is what you want the tulip to be, how it's behaving (existing with the rest of the picture).

Is the photo going to be a photo of a tulip—
"hey, what a beautiful tulip"—or is it going to be
a picture that compels you to want to look
more? Gee, this is such a simple art idea. The
whole photo means something, not just the
beautiful red tulip. The tulip is just the icing on
a very delicious cake. You have to make sure
the icing isn't too important—that it quietly
enhances, that it's adding to the cake and not
competing with it.

Jan Groover

[1]
JOHN RAWLINGS
Hands arranging flowers
Kodachrome
n.d.

[2] [3]
T O T O F R I M A
Untitled
Polaroid SX-70
1982

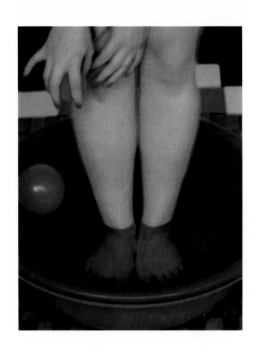

SARAH MOON
[4]
The Feet Bath
1998
[5]
The Bird
2000

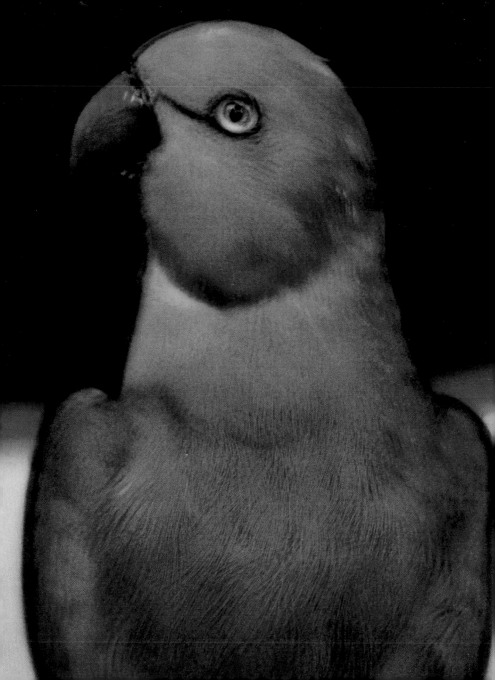

[6] [7]
J A N G R O O V E R
"Thoughts Angelico" series
Polaroid, 4" x 5"
1986

[8]
H I R O
Bonneville Salt Flats. Wendover (Utah)
14" x 11"
July 23, 1973

[9]
**CLAUS
GOEDICKE**
VII, 2
C-print Under Diaplex,
30" x 39"
1999

[11]
C H R I S T I A N V O G T
"Rouge" series
Polaroid, 8" x 10"
1976

JEAN-MARC TINGAUD
[12]
Maré
Dye Transfer
1990
[13]
Fouscaïs
Dye Transfer
1988

[14]
R O B E R T P O L I D O R I
Versailles
Circa 1980

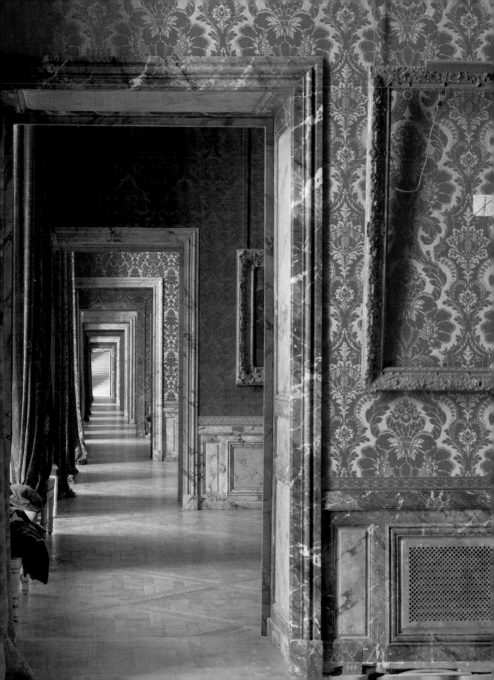

[15]
**R O B E R T
P O L I D O R I**
Versailles
Circa 1980

[16]
S H E I L A M E T Z N E R
Untitled
Circa 1980

visual researches

What I see isn't just colored—color takes part in the being of things, grass is green, our hair is fair, brown or black, etc. I design my photographs on the basis of this fact, reckoning color to be constituent. . .

Cézanne's observation about painting also goes for photography: "When color is at its richest, form is at its fullest. . ."

I take photographs by considering the presence of color in the material depth of things. . .

Color conveys meaning, the color blue is not just blue, it has a consistency, and shades, and it has a special liking for space and depth. . .

Red has an intensity. It emphasizes relief and galvanizes forms. Color ushers in a physical dimension which typifies, and which the image can use to advantage.

John Batho

PABLO GENOVÉS
[17]
Satellite
Cibachrome, 48" x 48"
2000
[18]
Tarta
Cibachrome, 48" x 48"
1999

PAOLO GIOLI
[19]
Ninfee Cromate
Polaroid Polacolor Type 59, 6" x 4¹ᐟ²"
1986
[20]
Natura morta calda
Polaroid Polacolor, 12" x 10"
1988

[21]
BOYD WEBB
Siren
62" x 48$^{1/2}$"
1988

[22]
A R T H U R T R E S S
Flying tubes, Arles
"The Preventorium Acide and Polychrome" series
12" x 16"
1985

Following pages:
[23]
J O H N B A T H O
Peas
Classic Ilfochrome, 12" x 16"
1984

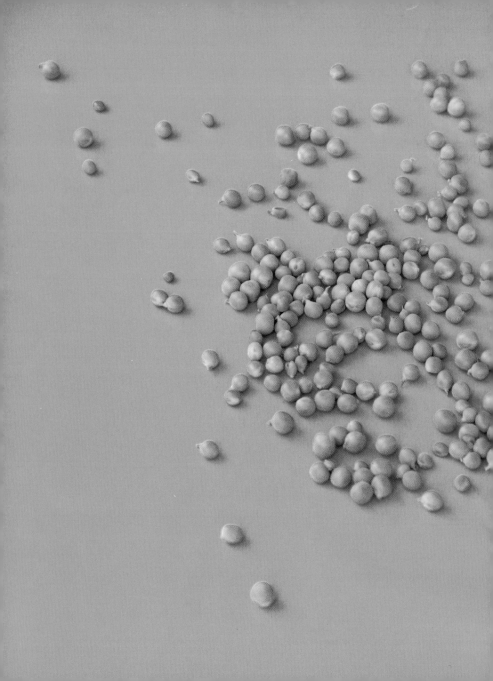

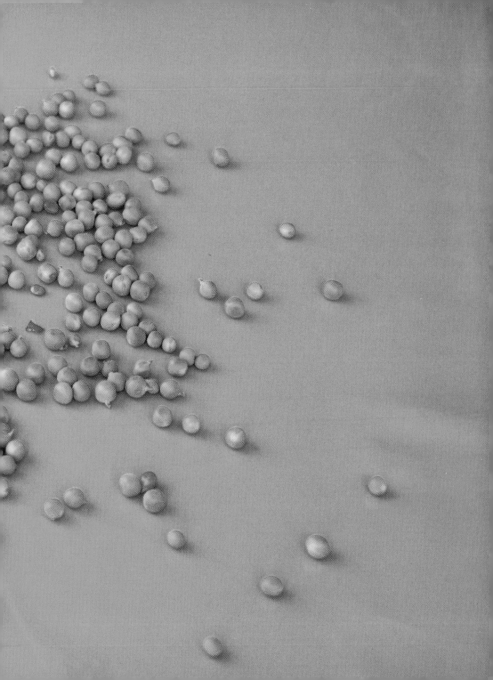

[24]
J O H N B A T H O
Orange floor and yellow canvas, Paris
Carbo print, Fresson process, 12" x 16"
1978

[25]
PATRICK TOSANI
Portrait n° 2
51" x 40"
1984

[26]
SANDY SKOGLUND
Shimmering Madness
1998

G E O R G E S R O U S S E
Chatou
Cibachrome on aluminum, 63" x 47"
1995

For me, there are not two kinds of photography—black and white, and color; rather, depending on the image I'm looking for, I can either add color or not and I decide this as I work, never before-hand. And for this reason, I've always enjoyed taking photographs with Polaroid film.

In looking for emotion and suggestion rather than realism, I reject the objectivity of color and use it in a highly subjective way. The magic of the photographic image is the indefinable mix of realism and fiction, abstract and concrete, illusion and truth.

Continuing to put up barriers between color and black and white is somewhat outmoded. Orson Welles said: "Color is for children, black and white for men." I think children have grown up quite a bit since then.

Paolo Roversi

[28]
HORST P. HORST
Schiaparelli dress, New York
1940

[29]
J O H N R A W L I N G S
Floating figure
Kodachrome
n.d.

[30] [31] [32]
L O U I S E D A H L - W O L F E
Published in Harper's Bazaar
Kodachrome
June 1957

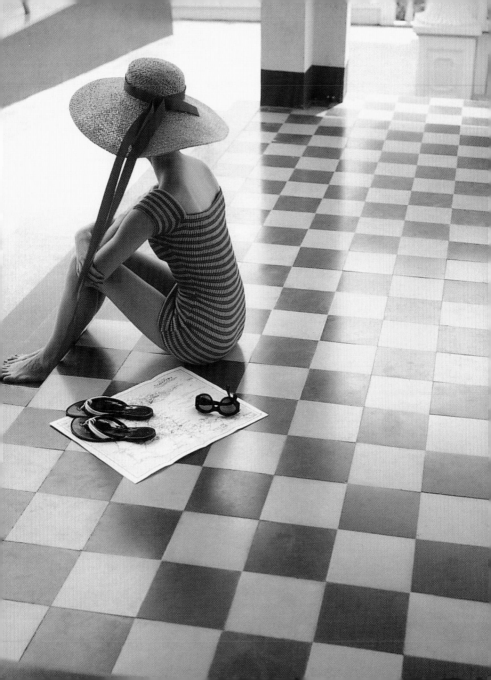

[33]
E R W I N B L U M E N F E L D
Woman Silhouetted under Red Cross
Published in Vogue *(cover)*
March 1945

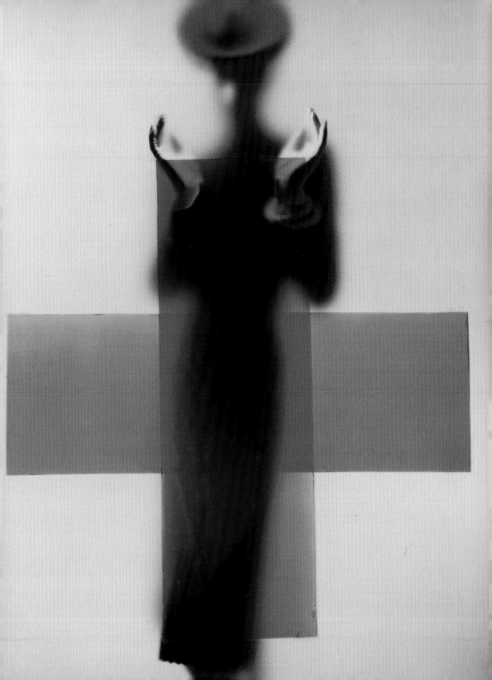

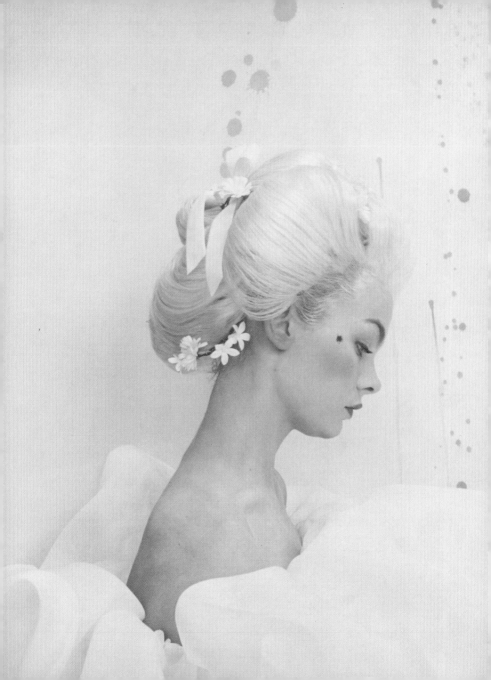

CECIL BEATON
Jean Shrimpton
Published in Vogue
1964

[35]
H E R B E R T M A T T E R
House Painters
n.d.

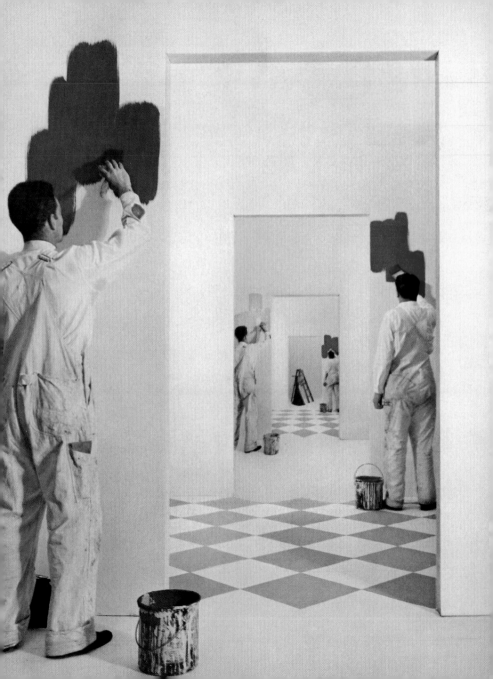

[36]
G U Y B O U R D I N
Campaign for Charles Jourdan
1970

JAVIER VALLHONRAT
[37]
Campaign for Christian Lacroix
Published in Globe Mode *magazine*
1987
[38]
Sybilla
1988

P A O L O R O V E R S I
[39]
Guineviere
Published in Yohji Yamamoto catalog (Fall-Spring 1997)
1996
[40]
Amber
1997

[41]
SERGE LUTENS
Ela
1978

SATOSHI SAIKUSA
Published in Vogue

NICK KNIGHT
[43]
Young Red Bustle
Published in Yohji Yamamoto catalog (Fall-Winter 1986-1987)
1986
[44]
Susie Bick smoking
Published in Yohji Yamamoto catalog (Fall-Winter 1988-1989)
1988

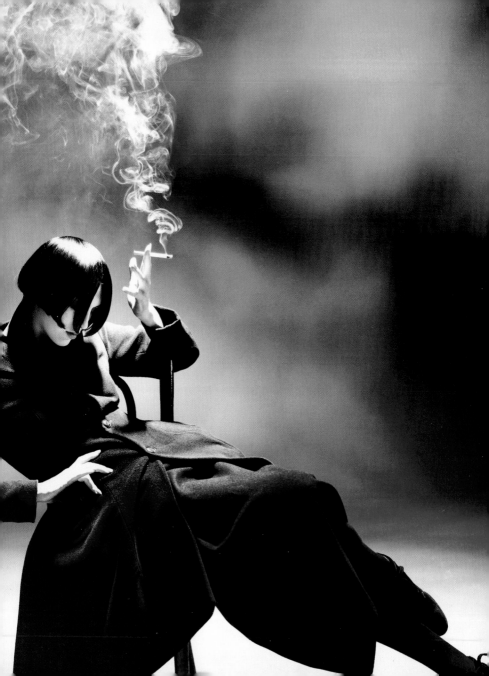

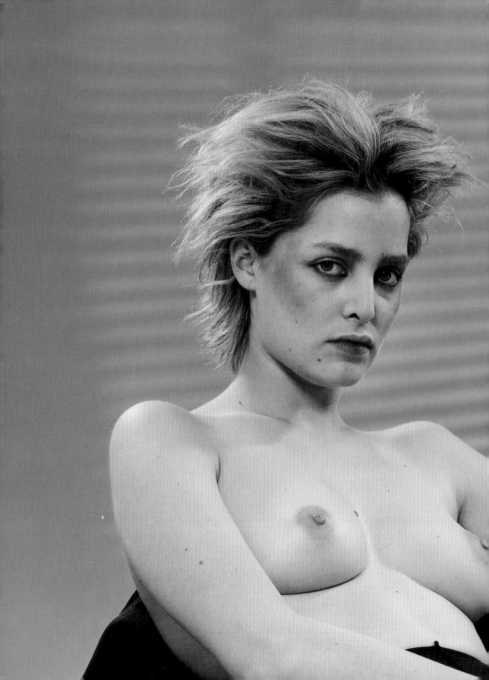

[45]
DAVID SIMS
Campaign for Yohji Yamamoto
1995

stage settings

I didn't think about color. My first film was
Ekta 120. I liked it so I carried on. For me,
color has never been either an end or a priority,
but dominants have come across, following
inner development, periods and serial
sequences. Temperatures, rather than shades
of color, lead me from the cold, from the blue
and the white of the "Long Holidays" to the
pale ochre of "The End of the Image" through
the warmth and heat of gold and fire in the
"Bedrooms" and the "Idols."

Bernard Faucon

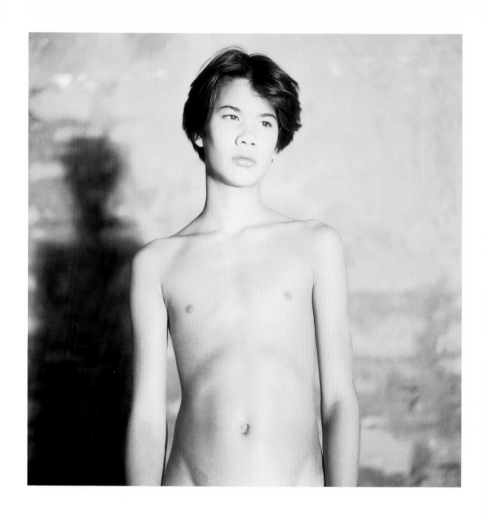

B E R N A R D F A U C O N
"Idoles et sacrifices" series
Fresson Process, 23²ᐟ³" x 23²ᐟ³"
1989-1991
[46]
Antoine
[47]
Le Petit Arbre

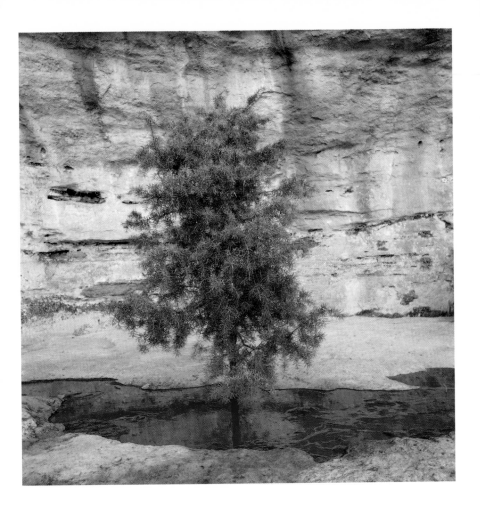

[48]
WILLIAM WEGMAN
Untitled
Polaroid, 24" x 20"
1999

Following pages:
[49]
PIERRE ET GILLES
Le Garçon au miroir, "Saynètes" series
Hand tinted
1984

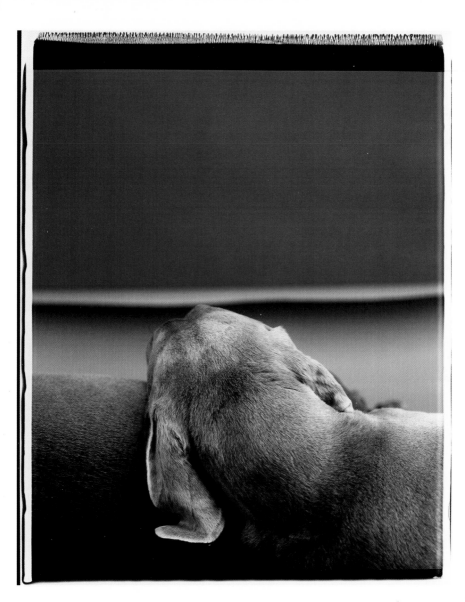

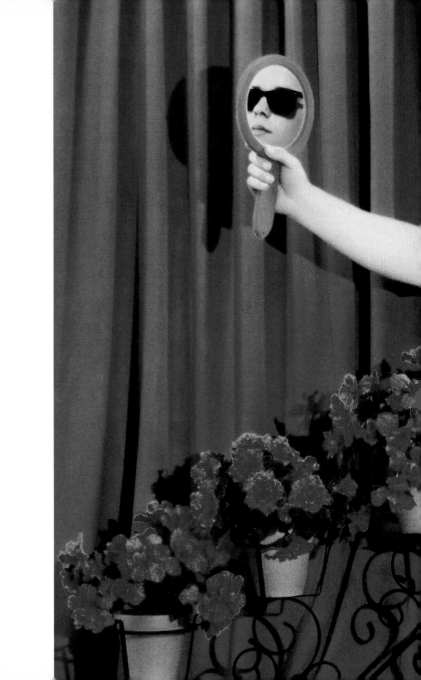

[50]
J A N S A U D E K
120 kilometers per hour
Gelatin-silver print, hand tinted
1974

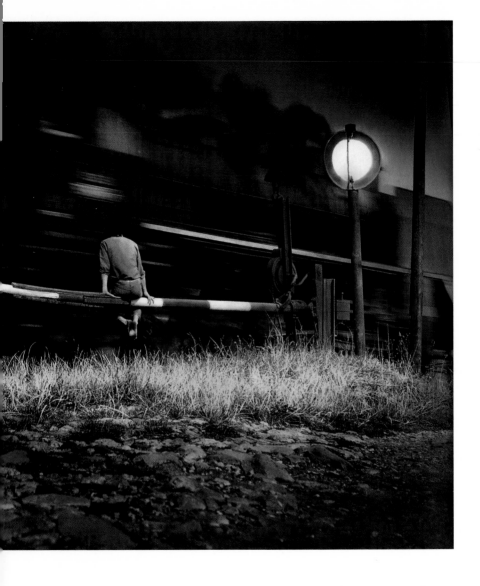

[51]
LUCAS SAMARAS
January 23, 1974,
Photo-Transformation #28 237
Polaroid SX-70

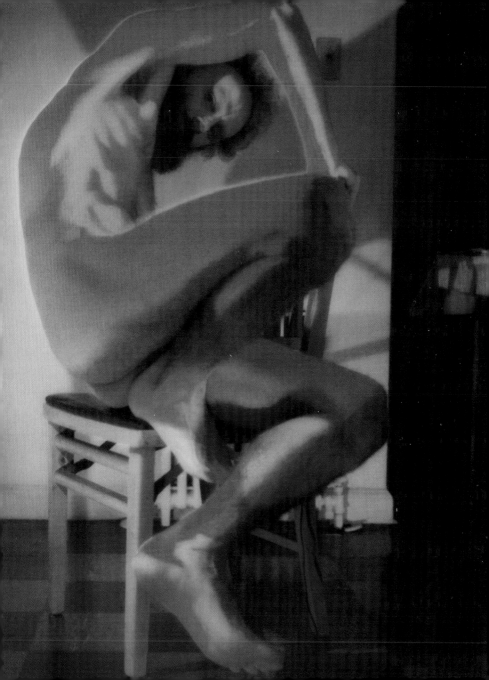

[52]
LUCAS SAMARAS
November 3, 1973,
Photo-Transformation #28 185
Polaroid SX-70

**YASUMASA
MORIMURA**
Criticism and the Lover A.
1990

A N D R E S S E R R A N O
[54]
Bloodscape X
Cibachrome, 27¹/²" x 40"
1989
[55]
Death by Fire, II, "The Morgue" series
Cibachrome, 50" x 60"
1992

portraits

After seeing the projection of my color portraits
of writers on June 23, 1939, Virginia Woolf
invited me to come back the next day and
photograph her.

In those days, color film was still so weak that
you could not take indoor shots, and I had to
count on the cooperation of my subjects. In
looking at the photos of Virginia that I publish
here, you will also notice that she is wearing
different dresses. Indeed, she had suggested
changing dresses because "one or the other
will be more photogenic for the color film."

Unfortunately, the war prevented me from showing her the results of my work. The film, of German manufacture (Agfacolor), could no longer be developed in France. I had to send the reels to America and have black-and-white prints made from these color negatives. . . . I suppose that Virginia, not having seen any photos, must have thought that I didn't want to show her these pictures.

Gisèle Freund

[57]
E D W A R D S T E I C H E N
Portrait of Lady H.
Autochrome
1908

GISÈLE FREUND
The Painter Pierre Bonnard, Le Cannet
1946

[59]
LISE SARFATI
Volodia and bananas, Moscow
Kodachrome
1994

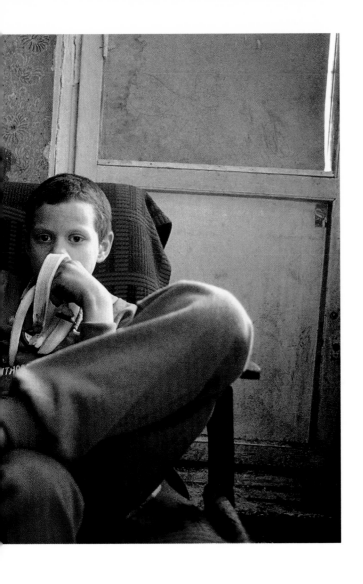

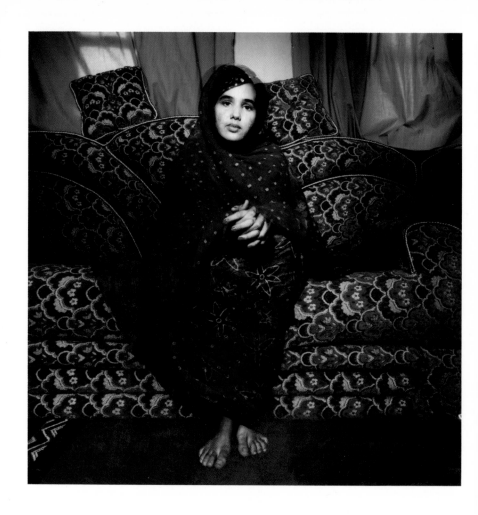

L A U R E N T M O N L A Ü
[60]
Portraits of Mauritania
1995
[61]
The Maurs, Khady and Meinnime, Novakchott
1995

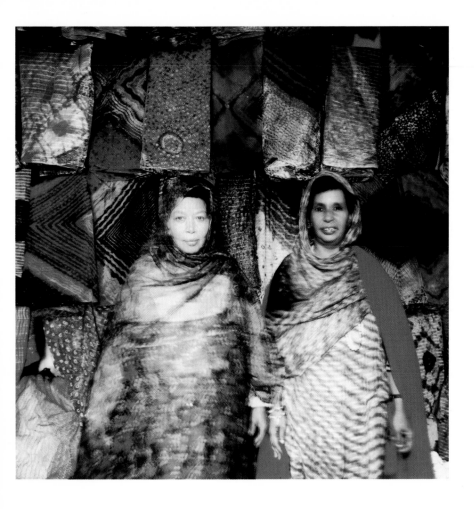

[62]
DENIS DAILLEUX
Cairo
15³/⁴" x 19²/³"
1995

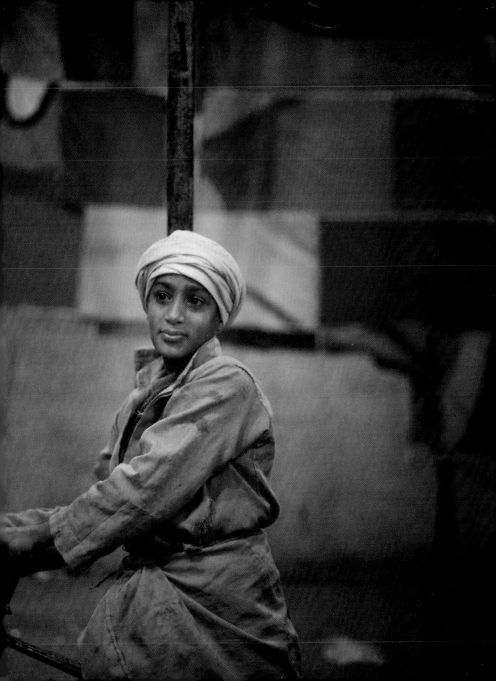

[64]
ANNIE LEIBOVITZ
David Byrne, Los Angeles
1986

[65]
O U K A L E L E
Madrid
Black and white argentic print retouched
with watercolor by the artist, 27$^{1/2}$" x 19$^{2/3}$"
1984

reportages

I find it surprising when I look back at all my early pictures. Early for me is the late 1960s and the beginning of the 1970s. I had begun shooting, like almost everyone, in black and white, doing my own prints in the darkroom and becoming a pretty good printer. Not a great printer. Just a good printer. But black and white seemed a very natural way to depict the world. My eye made the easy jump from graphic image to understanding that it represented some kind of reality. And while I was working all the time in black and white, I was always looking over my shoulder at color, trying to understand what it was about, and how to make that transition. *Life* and *Look* magazines were publishing a great deal of color in the early '70s, and it was obvious, since I knew I would someday be working for them (such hubris on my part!), that I, too, should learn about color.

Slowly, I began to see in color, and understand that there were so many new elements involved

in "seeing." No longer could you feel your way around a picture in the same way. Now with color, there were a number of technical problems thrown in (slow films & slower shutter speeds, sometimes a problem, particularly in dim light) as well as the aesthetic ones of form, juxtaposition and creating a mood. In some ways, learning to paint with the color camera provided a number of insights into my seeing which advanced beyond what I had done in black and white. The picture in the Kingston slum, for example, is a better picture in color. Besides the representational aspects of showing you what things really looked like, the subtlety of the colors in the man, the house, the bed, all create a calming feeling, contrasted with the intense and menacing eyes of the man in the green coat. I think this picture works well in color, as though it wasn't easy to make. I remember holding very still and shooting hand-held at about 1/8th@ f/2.8. I think the "slow" quality of the light, the mood, makes it work.

Harry Benson told me something I've never forgotten: "Treat color with contempt." I think he meant, don't be held hostage by it. Take your pictures, find your moments, and the color will work itself out. At a certain point in your photographic development, I think, you become completely attuned to color in a way which is almost without thinking. You see it, you feel it, you react and compose in color without really THINKING about it. Your mind develops to the point where you just instinctively react to your essential photographic Self. There are moments, as I think back, when I wonder what I was doing. In 1979, during the Iranian revolution, I found myself shooting Kodachrome 64. It became my film of choice, and more than once, I had made a news picture on Kodachrome which, because of its slow processing times (one to three days), was always arriving on editors' desks 48 to 72 hours after the Ektachrome E-6 shooters. But in many cases, the quality

of the Kodachrome image was such that if the deadline hadn't passed yet, my picture would get dropped into a layout at the last minute. Why? The color quality and sharpness of the Kodachrome was way ahead of the E-6 films, and in those days, quality still mattered. Now I look back at my pictures from Iran, and am very glad I was bothered enough to use Kodak, and not settle for the less sharp, less interesting color films in the name of expediency. My pictures still look as if they were shot yesterday. In that regard, they are like black and white. They remain in my archives like a good black and white negative. I think there is a tendency in news magazines today to use black and white when they want to be SERIOUS. Only for SERIOUS subjects done in a SERIOUS way. I'm a little sorry it has become so formulaic, since there are a great deal of stories which can be done SERIOUSLY in color, as well.

David Burnett

[66]
LARRY BURROWS
Vietnam
1966

Following pages:
[67]
ALEX WEBB
Grenade, Antilles
1979

[68]
ROBERT VAN DER HILST
Builder's yard, 2 A.M., Nan Jing Loo, Shangaï
Kodachrome 200
1994

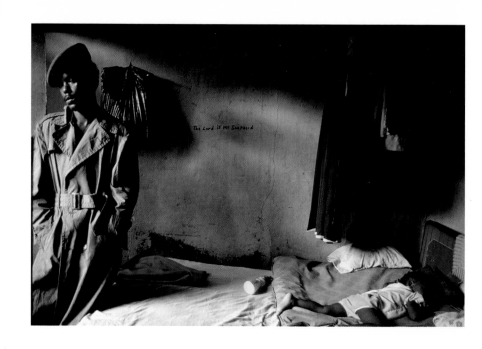

D A V I D B U R N E T T
[69]
Kingston Slum, Jamaica
1981
[70]
Sunrise in Port Maria, Jamaica
1982

Following pages:
[71]
S T É P H A N E D U R O Y
Halle, Deutschland (ex-RDA)
Kodachrome
1990

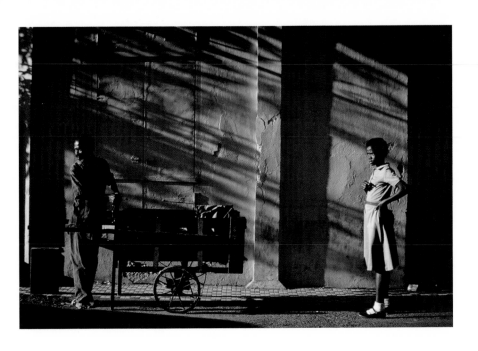

[72]
ERNST HAAS
The Cape, Pampelune
1956

Following pages:
[73]
JEAN-CLAUDE
COUTAUSSE
Easter Celebration, Vaudou, Haïti
Kodachrome
1996

Preceding pages:
[74]
R A G H U B I R S I N G H
The Morning, Panchganga Ghat, Bénarès
1986

Above:
[75]
G U E O R G U I P I N K H A S S O V
Ukranian Ballet, Paris
Kodachrome
1992

A L E X A N D R A B O U L A T
[76]
Sulfurmines, Java, Indonesia
2000
Following pages:
[77]
Afghan refugee in Shamshatoo camp, Pakistan
2001

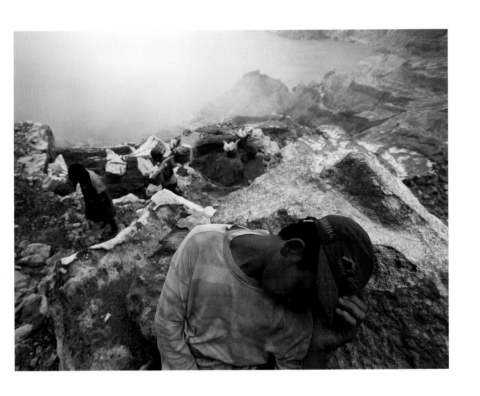

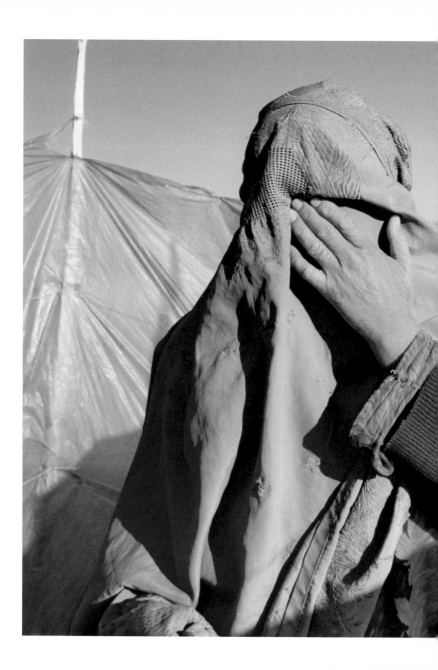

[78]
MIGUEL RIO BRANCO
Exercising at the Santa Rosa boxing academy, Rio
1993

Following pages:
[79]
DILIP MEHTA
Daula village, Haryana, India
January 1999

landscapes

Photography is about description. I don't mean only mere facts and the cold accounting of things in the frame. I really mean the description of sensations I get from things —color, surface, texture—and by extension, my memory of them under other conditions, as well as their connotative qualities. Color plays itself out along a rich band of feelings— color photography, as opposed to black and white, offers more wavelengths, more radiance, more sensation. I want to see and experience feelings from a photograph. Slow-speed color film gives us that capacity. A color photograph lets you study and remember how things look and feel in color. It enables you to have emotions along the full

range of the color spectrum, to retrieve emotions that are perhaps still in you from infancy—from the warmth and pinkness of your mother's breast to the lovely brown of your puppy's face, or the friendly, creamy yellow of your pudding. Color is always part of our experience. When we look at photographs that are in color, it's like looking at the world. Grass is green, not gray; flesh is luminous, not gray, the blue of the sky means different things to us at different hours. Black and white, by comparison, is a very cultivated and abstract response to the way we see. What are we all trying to get to in the making of anything? We're trying to get to ourselves. What I want is more of my feelings and less

of my thoughts. I want to be clear. I see
the photograph as a piece of experience itself.
It exists in the world. It is not a comment on
the world. In a photograph, you don't look for,
you look at! It's close to the thing itself. Color
is exciting! I want the experience that I am
sensitive to to pass back into the world, fixed
by chemistry and light to be reexamined.
That's what all photographs are about—
looking at things hard. I want to find an
instrument with the fidelity of its own
technology to carry my feelings in a true,
clear and simple way. Color offers us that.

Joel Meyerowitz

[80]
ERWIN BLUMENFELD
Times Square, New York
1951

Following pages:
[81]
ARTHUR SIEGEL
Untitled (Multiple Image of Street)
Dye Transfer
1947

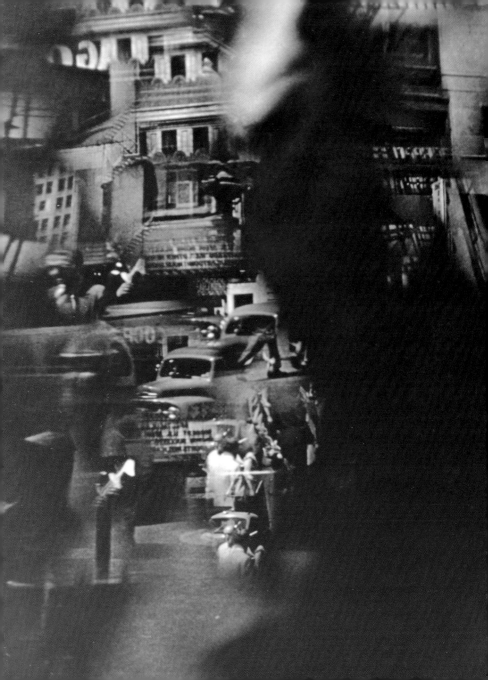

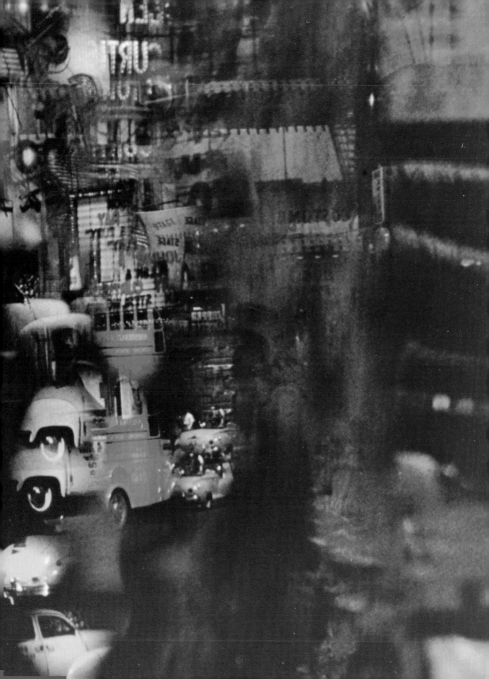

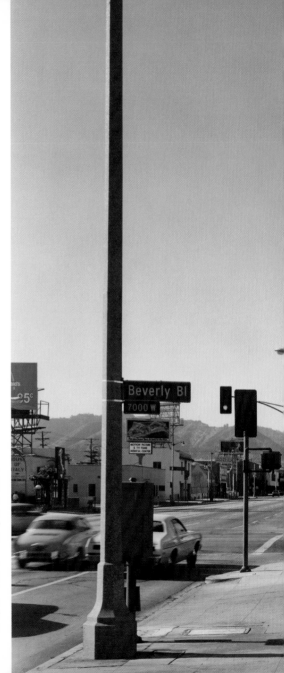

[82]
S T E P H E N S H O R E
*Brea Ave. and Beverly Blvd., Los
Angeles
Ektacolor*
1975

Following pages:
[83]
H A R R Y G R U Y A E R T
*Made in Belgium, Bruxelles
Kodachrome, Ink jet print*
1975

[84]
VINCENZO CASTELLA
Milano, series "Le Città dei Nomadi"
Cibachrome, 36" x 44$^{1/2}$"
1998

Following pages:
[85]
HARRY CALLAHAN
Ireland
Dye Transfer
1979

[86]
LUIGI GHIRRI
Solara (Mo)
Transparency, 2" x 3"
1985

[87]
LUIGI GHIRRI
Verso Bagno di Romagna (FO)
Transparency, 2" x 3"
1987

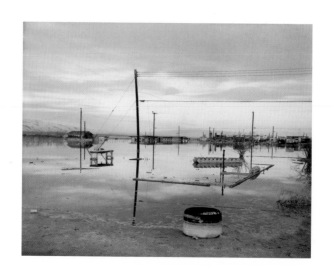

R I C H A R D M I S R A C H
[88]
Submerged House Foundation, Saltow Sea
1985
[89]
Desert Fire #1 (Burning Palms), "Canto IV: The Fires" series
1983

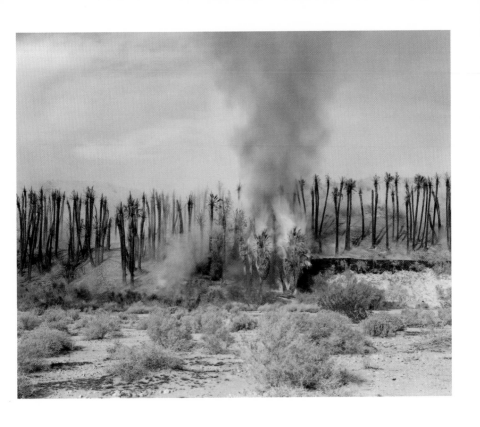

Following pages:
[90]
E L I O T P O R T E R
Lichen and Blueberry Leaves, Great
Spruce Head Island, Maine
Dye Transfer
1978

JOEL MEYEROVITZ
[91]
Bay/Sky, Slow Tide, Dusk
Vericolor, 8" x 10"
1984
[92]
Bay/Sky, Princetown
Vericolor, Repro Xpay, 4" x 5"
1977

Following pages:
[93]
ERNST HAAS
Monument Valley, Utah, USA
1962
[94]
PETE TURNER
Road and shapes/Road: NV, Shapes: Utah, USA
1971

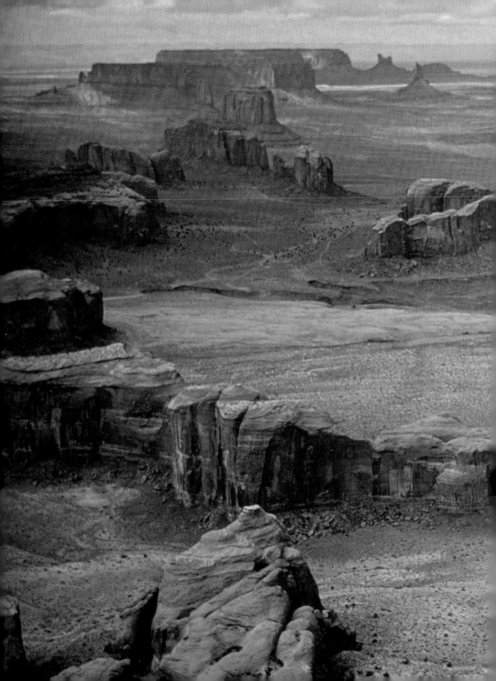

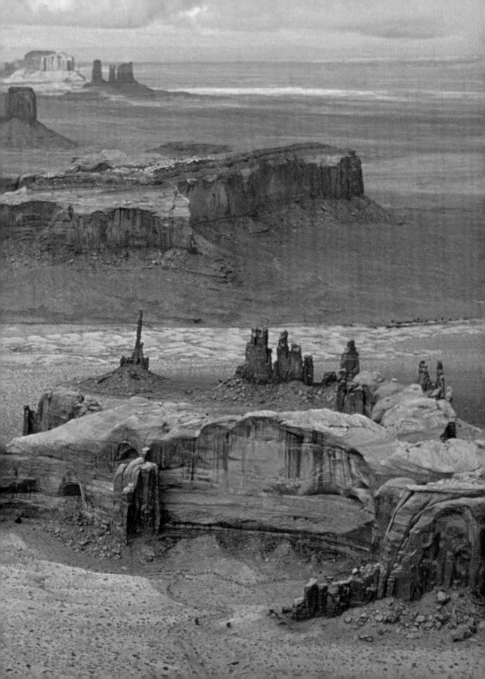

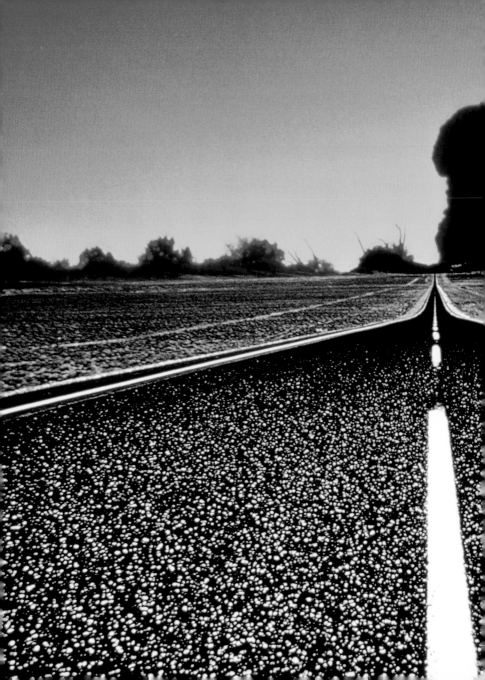

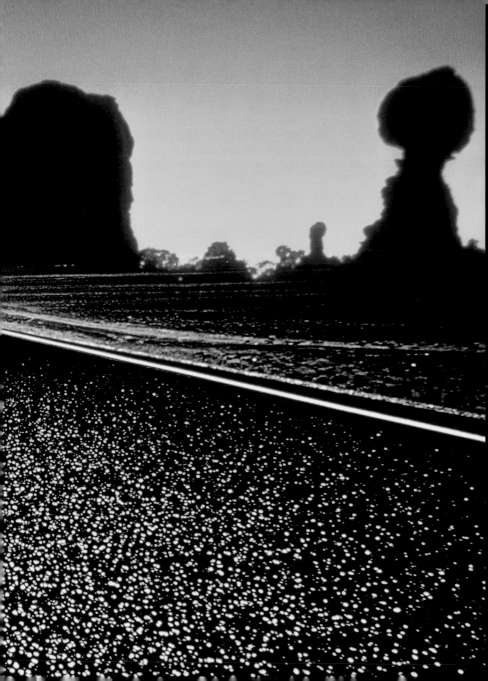

F R A N C O F O N T A N A
[95]
Cabine e Sabbia, Lido Delle Nazioni
1973
[96]
Landscape, Italy
1961
Following pages:
[97]
Landscape, Italy
1978

cities, world, and daily life

The practice of color and the practice of black and white evolved separately up until the 1980s. Today the two are merged. Photographers like Andreas Gursky and Philip-Lorca Dicorcia work with color with the same relevance as those who previously worked in black and white. Why regard photographers working in colors in isolation? There is no longer any reason to see any kind of difference whatsoever. This seems anachronistic to me. When I started with color, in the early 1980s, it's true that this difference did exist. Today, there's still color and black and white, but I no longer feel like saying: "I'm happier working in color than in black and white."

In my work, I don't separate color from the other components of the image. I don't deal

with it separately. If the color is dazzling, this is essential to what the image means. And an interpretation of the image encompasses this fact. But this doesn't mean that I'd approach black and white as I would color.

I don't think of myself as a color photographer, just as a photographer who introduced color into his work 18 years ago. For me, color gives meaning to the photograph, but it's not color, per se, that interests me. Color can't be dissociated from the subject because we see the world in color.

What is odd is that, when you see a black and white photograph, it doesn't look like the real world; it's an interpretation. In this sense, black and white is unusual, whereas color is quite simply normal.

Martin Parr

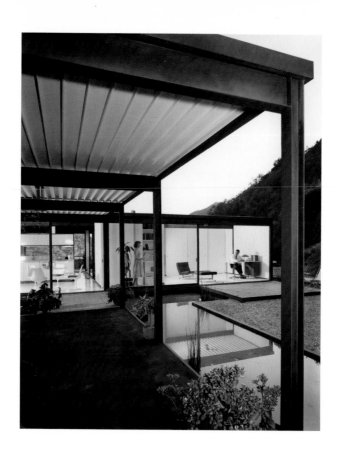

[98] [99]
J U L I U S S H U L M A N
Case Study House #21
(Pierre Koenig architecture)
Modern chromogenic print
1958

Following pages:
[100]
W I L L I A M E G G L E S T O N
Untitled (Greenwood, Mississippi)
Dye Transfer, 20" x 24"
1973

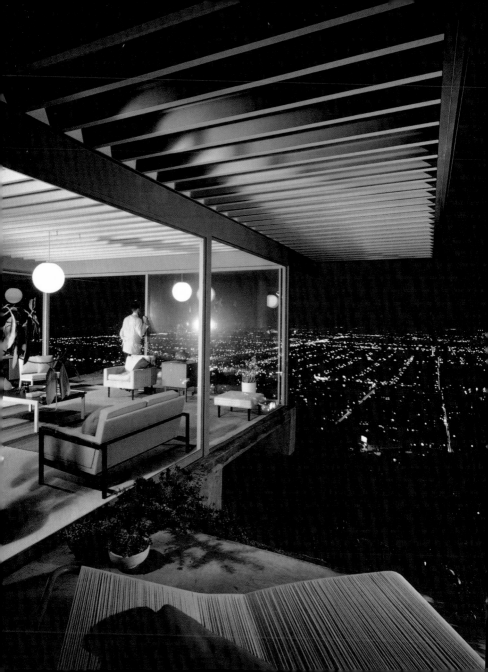

[101]
NEIL WINOKUR
Chef's knife
Cibachrome
1990

[102]
NEIL WINOKUR
Glass and water
Cibachrome
1990

Following pages:
[103]
THOMAS DEMAND
Studio
C. Diasec print, 6' x 11$^{1/2}$'
1997

MARK POWER
[104]
The Millenium Dome, London,
June 1st, 1999
[105]
The Millenium Dome, London,
May 21, 1999

[106]
C A N D I D A H Ö F E R
Gustave Monod high school, Enghien-les-Bains
1999

[107]
L A R S T U N B J O R K
The Offices, Sweden
39$^{1/3}$" x 39$^{1/3}$"
1998

[108] [109] [110] [111]
B E R T R A N D D E S P R E Z
Spring, Winter, Fall, Summer (Japan, 1998)
(from top to bottom, from left to right)
27$^{1/2}$" x 36"

[112]
GUIDO MOCAFICO
Green Line III, Beyrouth, October 1998

Following pages:
[113]
STÉPHANE COUTURIER
Rue de Châteaudun, Paris 9ᵉ
Cibachrome, 44" x 45"
1996

[114]
STÉPHANE COUTURIER
Paris, "Rive gauche" series
Cibachrome, 43" x 55"
1995

Following pages:
[115]
HUGER FOOTE
To Ed Giobbi, Memphis, Tennessee
Pigment Transfer, 20" x 14"
1995

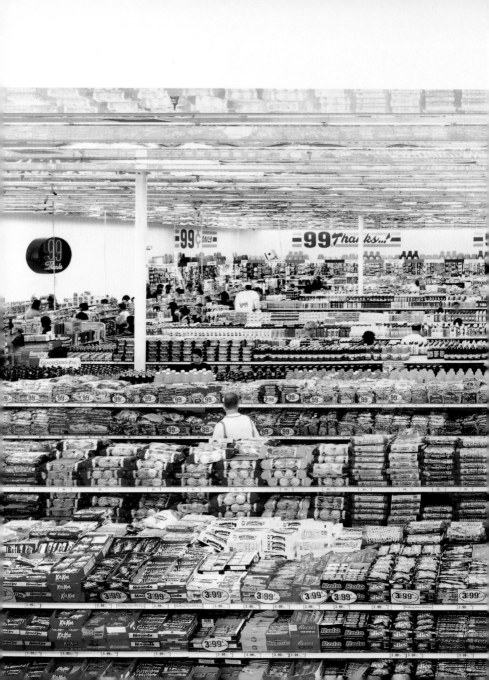

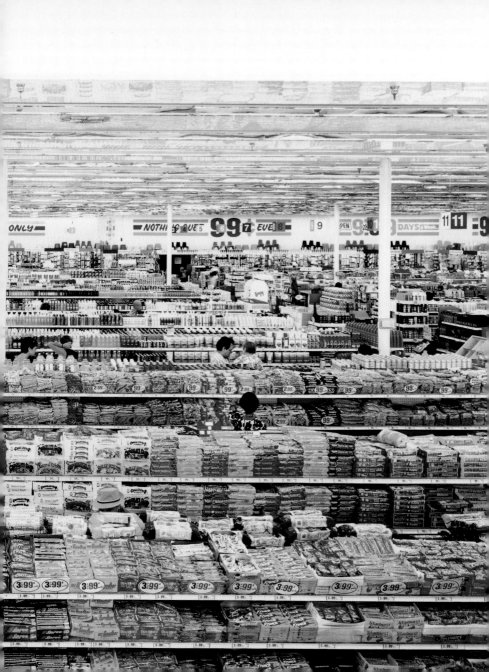

Preceding pages:
[116]
ANDREAS GURSKY
99 Cents
13³ᐟ⁴' x 7¹ᐟ⁴'
1999
[117]
GUEORGUI PINKHASSOV
London
1997

Opposite:
[118]
ROBERT WALKER
Times Square, New York
1988

Preceding pages:
[119]
MARTIN PARR
Santa Monica, USA, "Flowers" series
1999
[120]
CLARE STRAND
Mint, "Wasted" series
1999

Opposite:
[121]
NAN GOLDIN
Self Portrait in blue bathroom, London
1980

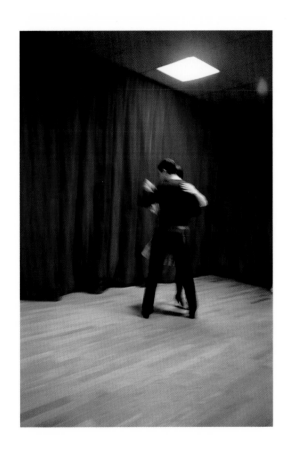

DOLORÈS MARAT
[122]
The Hotel, Paris 13[e]
Ektachrome 35 mm
1999
[123]
The Tango, Paris
Ektachrome 35 mm
1998

CHRONOLOGY

1666: Isaac Newton broke light down into seven basic colors, a discovery which would subsequently underpin research into the photographic reproduction of color.

1810: Goethe published his *Treatise on Colors (Zur Farbenlehre)*.

1839: The French chemist Eugène Chevreul published a theory titled *De la loi du contraste simultanée des couleurs*, which caught the attention of the Impressionists.

C. 1860: First research into color reproduction by Niépce de Saint-Victor, nephew of Nicéphore Niépce, the inventor of photography.

1861: The English physicist James Maxwell presented his studies on the additive synthesis of colors, creating an image by superimposing three filtered images in three colors: red, green, and blue.

1869: On the very same day—May 7—the Frenchmen Charles Cros and Louis Ducos du Hauron presented to the Société française de photographie two different methods for the subtractive synthesis of colors. Both were based on the three-color process principle and the use of negative films.

1900: The Lumière brothers showed some color photographs at the World's Fair in Paris. These early experiments led to the development of the autochrome. This process was based on the three-color process principle and additive synthesis. It used grains of potato starch, colored red, green, and blue; several million grains were pressed against a glass plate.

1907: The autochrome was marketed, arousing immediate interest, particularly from the American photographers Alfred Stieglitz and Edward Steichen, who ran the famous review *Camera Work*. The autochrome would be manufactured until 1932, with production rates at times reaching 6,000 plates a day.

1908: Gabriel Lippmann received the Nobel physics prize for inventing an extremely reliable color reproduction process, based on an interferential method (the interference of light rays). This process had been presented in 1891 at the Academy of Science, but could not be marketed, particularly on account of the excessively long time required for poses.

1909: Forty autochromes featured at the International Exhibition of Pictorial Photography, in New York. Albert Kahn started to compile photographic documentation in color based on autochromes (his archives today contain 72,000). Ducos du Hauron marketed a one-plate process, called the Omnicolor.

1910: The Belgian photographer Gustave Marissiaux tried out a new process developed by Joseph Sury, who trademarked it in 1908.

1912: Jacques-Henri Lartigue started to use autochromes.

1931: The Technicolor Motion Picture company developed color film for the cinema, which would be marketed in 1935, under the name Technicolor, based on the three-color process principle.

1935: Development, based on the principle of subtractive synthesis, of the Kodachrome film by two researchers, Leopold Mannes and Leo Godowsky. They were working for the Eastman Kodak company in Rochester, NY, which marketed this "slide" based on a chromogenic process—the coloring agents were added to film development trays and not to the emulsion itself. A second 35mm format version was launched in the following year.

1936: The German firm Agfa launched Agfacolor, a reversible film—the image was reversed when the film was developed.

1937: Louise Dahl-Wolfe's first fashion color photographs for the American magazine *Harper's Bazaar*.

1938: Gisèle Freund produced her first color portraits.

1939: Agfa developed a negative color film.

1940: First color TV broadcast.

1941: Harry Callahan's first color works.

1942: Marketing of Kodacolor paper and negative color film by the roll.

1943: Marketing of Agfacolor paper. Irving Penn produced his first cover for *Vogue* magazine. It was a composition based on objects, in color.

1945: Kodak launched the Dye Transfer printing process.

1946: Marketing of the Ektachrome film (Kodak).

1948: The Japanese developed the reversible Fujicolor film. It would be followed, ten years later, by a negative film, under the same name.

1952: The Fresson laboratories, near Paris, developed their carbon printing process, which would arouse ever greater interest, particularly because of the long-lasting quality of the prints obtained.

1959: Ektachrome film sensitivity was increased to 160 ASA.

1961: First edition of Johannes Itten's *L'Art de la couleur*, a reference book on the history of painting.

1963: Marketing of the Anscochrome film, with a 200 ASA sensitivity. It would rise to 500 ASA by 1968. The Cibachrome, a printing process involving discoloration, made its appearance on the market. Launch of Polacolor, an on-the-spot development process combining negative and positive, by the American firm Polaroid, which, back in 1947, had launched the first camera of this type, in black and white.

1968: Fuji launched a positive film, Fujichrome, which was compatible with Ektachrome developing processes. Its colors were more saturated.

1971: Ernst Haas published his book titled *La Création*, the culmination of a major project in color on the theme of Genesis.

1972: Launch of Polaroid's SX-70 system, an "integrated structure" film that was developed automatically, without any human intervention. Many photographers, including Lucas Samaras, would show great interest in this camera, which was very easy to handle, and even turn their backs on the normal development process.

1974: Kodak launched its E-6 development process for positive color films.

1976: Joel Meyerowitz produced his series of Cape Cod landscapes. William Eggleston exhibition at the MoMA, New York. Founding in New York of Contact Press Images, a photojournalists' agency which gave priority to color.

1978: Luigi Ghirri published *Kodachrome*, and Franco Fontana *Skyline*.

1979: The Eliot Porter exhibition Intimate Landscapes, at the Metropolitan Museum of Art in New York.

1980: Cibachrome II, a way of printing that amateurs can do and which requires the use of a mask. Cindy Sherman started using color in her self-portraits.

1981: Andreas Gursky, Candida Häfer and Thomas Ruff studied photography at the Düsseldorf Kunstakademie, in Bernd Becher's class. Sony introduced a magnetic camera that challenged the future of gelatin silver photography.

1983: Canon launched the first color photocopier, which some photographers would subsequently use to make shows.

1984: First negative color film with a sensitivity of 1600 ISO, marketed by Fuji.

1986: Martin Parr published *The Last Resort*, a reportage on the English seaside resort of Brighton, which set the tone for his later works.

1987: Nan Goldin showed *The Ballad of Sexual Dependency* at the Rencontres d'Arles photographic exhibition, a much acclaimed autobiographical work that she had published the year before in the United States.

1989: Frank Horvat, known above all for his fashion photographs, was one of the first people to experiment with digital editing. Using several different photographs, he created fantastic images.

1990: Polaroid published Volume V in the "Selections" series, which illustrated the enrichment of a collection that had been regularly exhibited for ten years. The collection included the works of artists using the process in varying formats, and color emulsions in particular.

1991: Kodak marketed a digital camera.

1992: Andres Serrano, The Morgue. Rineke Dijkstra embarked on his series of portraits on the beach.

1994: Epson launched the first color ink-jet printer—a machine which, together with the scanner, would win over more and more photographers. Photoshop, the picture retouching and photomontage software, appeared in a version that would swiftly be adopted as a market standard.

1995: Circulation of the exhibition devoted to the New York MoMA's photographic collections (1890–1965). Only two works in color were featured in the catalog: an Edward Steichen landscape and an Irving Penn still life.

1996: David LaChapelle published *LaChapelle Land*. Cibachrome is developed for digital enlargers. The following year, Ilford marketed the style of papers for the ink-jet printing that conserved color for a long period of time.

1997: First Paris Photo show, which, as a result of the participation of new galleries, would show the major presence of color in contemporary photographic work. This presence was confirmed in the art market by what was on view at the Paris FIAC (International Contemporary Art Fair) and at the Basel Fair in Switzerland.

1998: An exhibition titled Look at Me conveyed British cultural trends, to which a form of fashion photography based on brazen colors had been contributing since the early 1990s especially in the pages of magazines like *The Face, iD* and *Dazed and Confused*.

2001: William Eggleston Retrospective at the Fondation Cartier pour l'Art Contemporain in Paris. 250 photographs of ordinary life and things in the United States by this "inventor of color photography," as John Szarkowski called him.
Nan Goldin Retrospective at the Centre Georges Pompidou in Paris
"Open Ends," an Andreas Gursky show at the MoMA. The exhibition traveled to the Centre Georges Pompidou in Paris in 2002.

2003: Solo show of the work of Guy Bourdin at the Victoria and Albert Museum in London, which traveled the following year to the Musée du Jeu de Paume (Hôtel de Sully), in Paris
Ihei Kimura exhibition on Paris in the 1950s (1954 and 1955). The show is a rediscovery of his work and was part of the Rencontres d'Arles. It was also mounted at the Maison Européenne de la Photographie in Paris.

2005: Stephen Shore exhibition, Biographical Landscapes: Photographs from1968-1993 at the Musée du Jeu de Paume (Hôtel de Sully), in Paris. Organized by the Aperture Foundation.

Following pages:
[124]
ROBERT WALKER
Times Square, New York
2000

BIOGRAPHIES

John Batho was born in 1939 in Normandy. He came to the fore in France as the person who developed a radical involvement with color, in various photographic forms, all of them very spare.

Cecil Beaton was born in 1904 in Hampstead, England, and died in 1980 in London. His work as a fashion photographer was influenced by his links with painting and the theater.

Erwin Blumenfeld was born in 1897 in Berlin, and died in 1969 in Rome. He quickly introduced color to his daring visual works for fashion magazines such as Vogue and Harper's Bazaar.

Alexandra Boulat was born in 1962 in Paris. She became a professional photographer in 1989 and joined Sipa Agency. She covered the conflict in the former Yugoslavia. She contributes her photographs to numerous magazines, including *Time,* Paris *Match,* and *National Geographic,* and recently joined Cosmos Agency.

Guy Bourdin was born in 1928 in Paris, where he died in 1991. He made a name for himself in Vogue magazine through his novel approach to fashion, which was based on settings with surrealist overtones.

David Burnett was born in 1946 in Salt Lake City, Utah. After working for Time and Life magazines, at the Gamma agency, he co-founded Contact Press Images.

Larry Burrows was born in 1926 in London, and died in 1971 in Vietnam. He began working for Life magazine in 1942. His name is inseparable from his pictures of the Vietnam War.

Harry Callahan was born in 1912 in Detroit, Michigan, and died in 1999 in Providence, Rhode Island. His work is a methodical exploration of the creative possibilities of photography.

Vincenzo Castella was born in 1952 in Naples, Italy. He started out as a photographer in 1975, with an interest in the urban landscape; today he is reworking many of his pictures by computer.

Toni Catany was born in 1942 in Majorca, Spain. He has been living and working in Barcelona since 1960. His favorite subjects are the studio still life and the human body.

Jean-Claude Coutausse was born in 1960 in the Dordogne, France. His work with the newspaper *Libération* and the Contact Press Images agency directed him towards current events, an area he is now gradually moving away from.

Stéphane Couturier was born in 1957. He works in Paris and has focused on architectural photography since the early 1980s, as part of a project called "Urban Archaeology."

Louise Dahl-Wolfe was born in 1895 in California, and died in 1989 in San Francisco. The bulk of her work was done from 1936 to 1961 for *Harper's Bazaar.*

Denis Dailleux was born in 1958 in Angers, France. He specializes in portraiture in his work assignments for the press. He has been part of the Vu agency since 1995.

Thomas Demand was born in 1964 in Munich, Germany. He now divides his time between Berlin and London. His photographic work is based on paper sculptures.

Bertrand Desprez was born in 1963 in Douai, France. His early reports date from 1989. He works mainly for the press and is currently a member of the Vu agency.

Louis Ducos du Hauron was born in 1837 in Langon, and died in 1920 in Agen. From the early 1860s on word of his research into color photography spread abroad, and he focused on this form all his life.

Stephane Duroy was born in 1948 in Bizerte, Tunisia. He now lives in Paris. For several years, his documentary work has been largely on Germany.

William Eggleston was born in 1937 in Memphis, Tennessee. He is known as one of the first people to radicalize the use of color in photography using a documentary approach.

Bernard Faucon was born in 1950. He became known in 1997 for his photos that combine models and children.

Franco Fontana was born in 1933 in Modena, Italy, where he still lives. He became known for his landscapes; with geometric forms and sublimating colors, they verge on abstraction.

Huger Foote was born in 1961 in Memphis, Tennessee. He started as an assistant for fashion and portrait photographers. His personal work, however, is an exploration of the street.

Gisèle Freund was born in 1908 in Berlin, and died in 2000 in Paris. The bulk of her work consists of reportages and portraits, which was one of the first genres to practice in color.

Toto Frima was born in 1953 in The Hague, Netherlands. She currently lives and works in Amsterdam. She has been producing Polaroid self-portraits for more than 20 years.

Pablo Genovés was born in 1959 in Madrid, Spain. His work expressed an ongoing desire to manipulate images and imbue them with fantasy.

Luigi Ghirri was born in 1943 in Scandiano, Italy, and died in 1992. He left behind a work marked by subtle colors, and pictures showing a very poetic perception of his country.

Léon Gimpel was born in 1878 in Paris, and died in 1948. He joined the paper *L'Illustration* in 1904 as a photographer, and was the first person to use the Lumiere process in reporting.

Paolo Gioli was born in 1942 in Sarzano di Rovigo, Italy. He works mainly with Polaroid, and his experience as a painter prompted him to rework his pictures of faces and still lifes.

Claus Goedicke was born in 1966 in Cologne, Germany. Some of his compositions of objects may be seen as reinterpretations of the still lifes of the painter Giorgio Morandi.

Nan Goldin was born in 1953 in Washington, D.C. She came to notice in 1983 for her direct photography in a book about her private life and the lives of her nearest and dearest.

Jan Groover was born in 1943 in New Jersey. She now lives in southwest France. She started out as a painter, but became involved with photography in the 1970s.

Harry Gruyaert was born in 1941 in Antwerp, Belgium. He studied film, then went to work in Paris. He joined Magnum in 1981, where he was one of the few photographers working in color.

Andreas Gursky was born in 1955 in Leipzig, Germany. Along with Thomas Struch, he currently embodies a new school of urban landscape, inspired by the teaching of Bernd Becher.

Ernst Haas was born in 1921 in Vienna, Austria, and died in 1986 in New York. As a member of Magnum, he stood out for his research in color, which he adopted at a very early stage.

Hiro was born in Shanghai in 1930. He now lives and works in New York. For many years he worked with the magazine *Harper's Bazaar*, and has produced highly sophisticated compositions.

Candida Höfer was born in 1944 in Eberswalde, Germany. She studied photography in Düsseldorf, where she met members of the young German landscape school.

Horst P. Horst was born in 1906 in Weissenfels, Germany, and died in 1999 in Florida. He began taking photographs for *Vogue* in 1931. His pictures show his fondness for the fashion world

Nick Knight was born in 1958 in London. He works for the press and advertising, and is known for his visual innovation. His clientele includes the couturier Yohji Yamamoto.

Jacques-Henri Lartigue was born in 1894 in Courbevoie, and died in 1986 in Nice. He started taking photos at the age of 8 and experimented in turn with the snapshot, the autochrome, the pan, and stereoscopy. His work was recognized in the 1960s.

Annie Leibovitz was born in 1949 in Connecticut. In 1982, after many reports on the music world, she began working for *Vanity Fair* as a portrait photographer.

Gabriel Lippmann was born in 1845 in Luxembourg, and died in 1921. He was a physician who became involved in color photography, among other things. His archives are held at the *Musee de l'Elysee* in Lausanne.

Serge Lutens was born in 1942 in Lille, France. He took his first photographs in 1969, for Dior. In 1980, he started to work with Shiseido, and his experience goes well beyond photography.

Dolorès Marat was born in 1944 in Paris. In 1983, she embarked upon a personal research project based on an impressionist-like style. This is her trademark today.

Gustave Marissiaux was born in 1872 in Marne-les-Mines, and died in 1929 in Cagnes-sur-Mer. His work was inspired by pictorialism. It was donated in 1994 to the Musee de la Photographie in Charleroi.

Herbert Matter was born in 1907 in Engleberg, Switzerland, and died in 1984. He produced posters inspired by the avant-garde of the 1930s, then worked for *Harper's Bazaar* magazine. His photographs often overlapped with the art of his time.

Dilip Mehta was born in 1952 in New Delhi, India. He moved to Canada and then joined the Contact Press Images agency in New York. Today, his work focuses mainly on the country of his birth.

Sheila Metzner was born in 1939 in New York. Her style, which is most evocative in still lifes, updates the traditions of a pictorialist style of photography.

Joel Meyerowitz was born in 1938 in New York. He became a photographer in 1962, focusing on landscape using a tremendous mastery of color.

Richard Misrach was born in 1949 in Los Angeles. He works with landscapes—black and white to start with, then color—in which natural phenomena and accidents occur that enliven the representation.

Guido Mocafico was born in 1962 in Vevey. He now lives in Paris, but regularly works for advertising companies and contributes fashion pieces to the Italian and British press.

Laurent Monlaü was born in 1957 in Marseilles. He started taking photographs in the late 1970s, and has been a Rapho member since 1994. He works frequently in Africa.

Sarah Moon was born in 1941 in France. She worked first in fashion and advertising, then, in tandem, developed an oeuvre as a filmmaker, alternating commercials with documentary and films.

Yasumasa Morimura was born in 1951 in Osaka, Japan. He stages his own body in sets that are like so many winks at the history of painting and film.

Ouka Lele was born in 1957 in Madrid, Spain. She embodies a new generation of photographers taking part in the Movida. Her way of repainting her photographs and her inspiration are very distinctive.

Paul Outerbridge was born in 1899 in New York, and died in 1958 in California. His artistic training prompted him to create highly composed images. He was one of the first people to tackle the nude in color.

Martin Parr was born in 1952. He lives in Bristol, England. In the 1980s, he broached color, which gave a new critical dimension to his view of British society and culture.

Pierre et Gilles met in 1976. They live and work in Paris, one taking photos, the other painting. Their subjects and style have remained the same since the early days of their joint work.

Gueorgui Pinkhassov was born in 1952 in Moscow, Russia. He worked in film as a cameraman, then as a still photographer. He arrived in Paris in 1985, where he photographed Soviet minorities, and joined the Magnum agency.

Robert Polidori was born in 1951 in Montréal and lives in New York since 1969. He became involved in photography after studying cinema. He focuses on various kinds of places whose memory he tries to capture.

Eliot Porter was born in 1901 in Illinois, and died in 1990. Early on, he became involved with color combined with subjects inspired by the spectacle of nature.

Mark Power was born in 1959 in Brighton, England, where he currently lives and works. He became involved in documentary photography in 1982. He is a member of the Network agency in London.

John Rawlings was born in 1911 in Ohio. He worked mainly as a fashion photographer for *Vogue* magazine until the 1960s.

Miguel Rio Branco was born in 1946 in the Canary Islands. He lives in Brazil, and joined Magnum in 1978. Painting, which was his area of activity in the early years, lies at the root of his fondness for color.

Georges Rousse was born in 1947 in Paris, where he currently lives and works. His work is focused mainly on very geometric reinterpretations of space.

Paolo Roversi was born in 1947 in Varenne, Italy. He currently lives and works in Paris. He devotes most of his time to fashion photography for magazines.

Satoshi Saikusa was born in Japan in 1959. He arrived in Paris in 1984 and started taking photographs two years later for *Vogue* magazine among others. He made his first commercials in 1988.

Lucas Samaras was born in 1936 in Greece. He lives and works in the United States. His work is based on experiments with Polaroid and portraiture.

Lise Sarfati was born in 1958 in Oran, Algeria. She went to Russia for the first time in 1990, where she now works regularly, specifically with children. She is a member of the Magnum agency.

Jan Saudek was born in 1935 in Prague, Czech Republic. He was not recognized as a photographer in his own country until 1984, after working for many years in a printing press.

David Seidner was born in 1957 in Los Angeles, and died in 1999 in Miami. His approach to fashion was hallmarked by a fondness for elegant compositions.

Andres Serrano was born in 1950 in New York. He studied fine art, then became involved with photography. Inspired in his early years by religious themes, he attracted considerable criticism.

Stephen Shore was born in 1947 in New York. His work focused on the urban landscape, which in turn prompted him to make intensive explorations in North America.

Julius Shulman was born in 1910 in Brooklyn, New York. From 1936 to 1968, he worked with the architect Richard Neutra, photographing all his works.

Arthur Siegel was born in 1931 in the United States and died in 1978. He studied at the Bauhaus school when it moved to Chicago. He was one of the first people to use 35mm format color.

David Sims arrived in London in 1984 and worked as an assistant. Ten years later, he was one of the most acclaimed fashion photographers in London espousing a style that contrasted run-of-the-mill glamour.

Raghubir Singh was born in 1942 in Jaipur, India, and died in New York in 1999. He became a professional photographer in 1965, and published his first book on India in 1974. He tirelessly photographed all the main regions of the subcontinent.

Sandy Skoglund was born in 1946 in the United States. She has developed a style that is primarily installation-like, with monochrome sculptures placed in the set.

Edward Steichen was born in 1879 in Luxembourg, and died in 1973 in the United States. He was a prolific and varied photographer. He was also director of photography at the Museum of Modern Art in New York.

Clare Strand was born in London in 1973. Today, she lives and works in Brighton. She is known for her 1997 series of portraits titled "Seeing Red."

Jean-Marc Tingaud was born in 1947 in Saulieu, France. He currently lives in Paris. On his travels, particularly around the Mediterranean, he focuses mainly on interiors.

Patrick Tosani was born in 1954 in France. He is a representative of the very contemporary photography intentionally aimed at what one critic has called the "picture form."

Arthur Tress was born in 1940 in Brooklyn, New York. After black and white work produced in a fantasy-rich vein, he tackled color and compositions where fantasy blended with a very visual approach.

Lars Tunbjork was born in 1956 in Boras, Sweden. He started his career in 1975, setting up shop in Stockholm where he worked at a newspaper. As a freelance photographer, he is represented by the Vu agency.

Pete Turner was born in 1934 in Albany, New York. His career got underway in the late 1950s, and he made a name for himself with pictures showing highly contrasting colors.

Javier Vallhonrat was born in 1953 in Madrid. Today, he is one of the most productive European fashion photographers, and his pictures have long showed his fondness for painting.

Robert Van der Hilst was born in 1940 in Amsterdam. He now lives in Paris, but spends much of his time traveling the world for magazines such as *Marie-Claire.*

Christian Vogt was born in 1946 in Basel, Switzerland, where he now lives and works. His work is extremely varied: nudes, portraits, landscapes and still lifes.

Robert Walker was born in 1945 in Montreal. He moved to New York in 1978 and took part in several major exhibitions in the United States on the theme of color. One of the exhibits was at the George Eastman House in Rochester.

Alex Webb was born in 1952 in San Francisco. He became a member of Magnum in 1979. He worked a great deal in color in the Caribbean, Mexico and Africa.

Boyd Webb was born in 1947 in New Zealand. He is now based in London. His work, which often includes animals, shows a wild streak of fantasy.

William Wegman was born in 1943 in the United States. His name is closely associated with pictures of his dog, Man Ray, and his use of Polaroid.

Edward Weston was born in 1886 in the United States, and died in 1958. He was the leading figure in a style of photography with extremely pure forms, focusing on the nude and the still life.

Neil Winokur was born in 1945 in New York. In the early 1980s, he exhibited portraits, but he is better known for his everyday objects photographed in very pop colors.

PHOTOGRAPHIC CREDITS